Forest of a
Thousand Daemons

Forest of a Thousand Daemons

A HUNTER'S SAGA

D.O. Fagunwa

Being a translation of
Ogboju Ode Ninu Igbo Irunmale
by WOLE SOYINKA

Illustrated by Bruce Onobrakpeya

City Lights Books | San Francisco

Cover design by Linda Ronan
Illustrations by Bruce Onobrakpeya

Library of Congress Cataloging in Publication Data
Fagunwa, D. O.
[Ogboju ode ninu igbo irunmale. English]
Forest of a thousand daemons: a hunter's saga / D.O. Fagunwa
M.B.E.; Being a translation of Ogboju Ode Ninu Igbo Irunmale
by Wole Soyinka; Illustrated by Bruce Onobrakpeya.
 pages cm
Translation of Ogboju Ode Ninu Igbo Irunmale by Wole
Soyinka, Yoruba to English.
ISBN 978-0-87286-630-0
I. Title.

PL8824.F27O313 2013
823 — dc23

 2013013795

City Lights Books are published at the City Lights Bookstore
261 Columbus Avenue, San Francisco, CA 94133
www.citylights.com

Translator's Note

The pattern of choices begins quite early, right from the title in fact. Is *Irunmale* to be rendered literally 'four hundred deities' rather than in the sound and sense of 'a thousand' or 'a thousand and one'? Again, in one of the extracts which I translated for the magazine *Black Orpheus*, this phrase *'mo nmi ho bi agiliti'* which became 'my breath came in rapid bloats like the hawing of a toad' aroused some protest from a critic. Indeed *agiliti* is far from being the toad, it is more a member of the lizard species. But then neither toad nor lizard is the object of action or interest to the hero Akaraogun or his creator Fagunwa at this point of narration. Fagunwa's concern is to convey the vivid sense of event, and a translator must select equivalents for mere auxiliaries where these serve the essential purpose better than the precise original. In what I mentally refer to as the 'enthusiastic' passages of his writing, the essence of Fagunwa is the fusion of sound and action. To preserve the movement and fluidity of this association seems to be the best approach for keeping faith with the author's style and sensibility.

To go back to the first example, I have not only discarded the earlier 'four hundred gods', but now consider 'daemon' closer in essence to *imale* than gods, deities or demons.

The spelling is important. These beings who inhabit Fagunwa's world demand at all costs and by every conceivable translator's trick to be preserved from the common or misleading associations which substitutes such as *demons*, *devils* or *gods* evoke in the reader's mind. At the same time, it is necessary that they

transmit the reality of their existence with the same unquestioning impact and vitality which is conveyed by Fagunwa in the original.

Fagunwa's beings are not only the natural inhabitants of their creator's haunting-ground; in Yoruba, they *sound* right in relation to their individual natures, and the most frustrating quality of Fagunwa for a translator is the right sound of his language. This most especially has been responsible for my resorting to inventive naming ceremonies for some of his unfamiliar beings. The other solution, that the names remain in their original, is not so satisfactory, as the names no longer possess the same non-exotic validity in a new lingual surrounding.

Fagunwa's style fluctuates, for he is both the enthusiastic raconteur and pious moralist, and the battle of the inventive imagination with the morally guided is a constant process in much of his work. His total conviction in multiple existences within our physical world is as much an inspiration to some of the most brilliant fiction in Yoruba writing as it is a deeply felt urge to 'justify the ways of God to man'. The experience of sheer delight in his verbal adroitness is undoubtedly a great loss in translation, but is not reason enough to limit Fagunwa to the readership of Yoruba speakers only. As Fagunwa himself would have put it, *'onisango ∂i kiriyo, o l'oun o jo bata, ijo o gbo ∂uru, ejika ni kōtu fa ya.'** The essential Fagunwa, as with all truly valid literature, survives the inhibitions of strange tongues and bashful idioms. But enough. *'Enu ko la nfi pe olowo ilu.'*† Let the story-teller himself persuade us.

W.S.

* The Christian convert swore never again to dance to Sango drums; when he heard the church organ, his jacket soon burst at the seams.
† Good drumming requires no advertisement.

Glossary of Yoruba and unfamiliar words

1 Agidigbo
Yoruba leisurely music played mostly at social occasions. The instruments include a resonance box with metal strips for plucking.

2 Ado, ato
Small gourds for storing powder charms.

3 Alagemo
A masquerade of the cult of the dead.

4 Ayo
A game, played with seeds in a wooden tray.

5 Babalawo
A priest of 'ifa', *below*.

6 Bembe
A drum, with a deep rumbling resonance.

7 Buba
Yoruba light smock.

8 Dandogo
Yoruba dress, formal.

9 Eko
Corn mealie.

10 Gangan
Yoruba tonal drum, usually with a range of an octave or more.

11 Ghommid (iwin, oro)
A generic term for beings neither human nor animal nor strictly demi-gods, mostly dwellers in forests where they live within trees. Can be brought into human surroundings through incantations and charms. The ghommid family include: —

12 Bog-troll (ẹbọra)	A soot-black ghommid with glistening skin;
13 Dewild (ewele)	Close in appearance to the gnom, *below*, but far more dangerous and unruly;
14 Gnom (egbere)	A close relation of the dewild, *above*, but a little more substantial, and although prone to tears, capable of constituting a menace to humans;
15 Kobold (eseku)	A gnom, with some essence of the dead;
16 Spirits (anjọnu, oro)	Re-incarnated spirits of the dead.
17 Ifa	Divination.
18 Kijipa	Thick durable hand-woven cloth.
19 Ogede	A spell for paralysing an enemy.
20 Sanyan	Brown woven cloth, much valued.
21 Segi	A kind of coral bead, much valued.
22 Agbada	Yoruba gown.
23 Eba	Food made from cassava flour.
24 Egbe	A spell giving one the power to become invisible.

Forest of a
Thousand Daemons

1

THE AUTHOR MEETS AKARA-OGUN

My friends all, like the sonorous proverb do we drum the *agidigbo*; it is the wise who dance to it, and the learned who understand its language. The story which follows is a veritable *agidigbo*; it is I who will drum it, and you the wise heads who will interpret it. Our elders have a favourite proverb — are you not dying to ask me how it goes? — they tell it thus, 'When our masquerade dances well, our heads swell and do a spin.' Forgive my forwardness, it is the proverb which speaks. Now I do not want you to dance to my drumming as a mosquito to the deep *bembe* drums, its legs twitching haphazardly, at loggerheads with the drums. Dance my friends, in harmony, with joy and laughter, that your audience may ring your brows with coins and pave your path with clothing; that men may prostrate before you and women curtsey in sheer pleasure at your dancing. But for a start, if you want this dance to be a success, here are two things I must request of you. Firstly, whenever a character in my story speaks in his own person, you must put yourselves in his place and speak as if you are that very man. And when the other replies, you must relate the story to yourselves as if you, sitting down, had been addressed and now respond to the first speaker.

In addition, as men of discerning — and this is the second task you must perform — you will yourselves extract various wisdoms from the story as you follow its progress.

Well, I do not want to say too much at the start lest I become a loquacious fool, one who deserts the

clearly blazed path and beats about the bush. I will rather now take up my drum and set to it, and I request you to adjust your *agbada*, toss its sleeve properly over your shoulder, prepare yourselves for dancing, that the affair may dovetail neatly in the spirit of the saying, 'I can dance and you can drum; this is the meeting of two grubs.' That, forgive me, is a proverb of our elders.

It all began one beautiful morning; a clear day-break it was, the harmattan haze had retreated home, the creatures of the forest were still asleep, those of the backyard were feeding on the day's providence and birds were singing praises of their Maker. A beatific breeze rustled the dark leaves of the forest, deep dark and shimmering leaves, the sun rose from the East in God's own splendour, spread its light into the world and the sons of men began their daily perambulations. As for me I sat in my favourite chair, settled into it with voluptuous contentment, enjoying my very existence.

Not long after I was seated an old man came up to me and greeted me. I returned him courtesy for cour-tesy. Observing what appeared to be a desire to stay I offered him a chair and turned it to face me. Once seated, we began to exchange pleasantries and share jokes like old acquaintances. But it was not very long after when I heard the man sigh deeply as one whose mind was troubled by a heavy thought. Even as I be-gan to consider asking him the cause, he began himself to speak thus:

'Take up your pen and paper and write down the story which I will now tell. Do not delay it till another day lest the benefit of it pass you over. I would not myself have come to you today, but I am concerned about the future and there is this fear that I may die unexpectedly and my story die with me. But if I pass it on to you now and you take it all down diligently, even

when the day comes that I must meet my Maker, the world will not forget me.'

When he had spoken thus I hurried to fetch my writing things, brought them over to my table, settled myself in comfort, and let the stranger know that I was now prepared for his tale. And he began in the words that follow to tell me the story of his life —

My name is Akara-ogun, Compound-of-Spells, one of the formidable hunters of a bygone age. My own father was a hunter, he was also a great one for medicines and spells. He had a thousand powder gourd-lets, eight hundred *ato*, and his amulets numbered six hundred. Two hundred and sixty incubi lived in that house and the birds of divination were without number. It was the spirits who guarded the house when he was away, and no one dared enter that house when my father was absent—it was unthinkable. But deep as he was in the art of the supernatural, he was no match for my mother, for she was a deep seasoned witch from the cauldrons of hell.

Once my father had nine children, of whom I was the eldest; four wives and my mother was the most senior of them. She had four children, the wife who was next to her had three, the next two and the fourth had none at all. One day my mother and another of these wives had a quarrel and took the case to my father for settlement. He found my mother at fault and this so angered her that she resolved to take vengeance for the slight. She became so ruthless in her witching, that, before the year was out, eight of my father's children were dead and three of his wives had gone the same way. Thus was I left the only child and my mother the only wife.

Look on me, my friend, and if you are not yet married I implore you to consider the matter well before

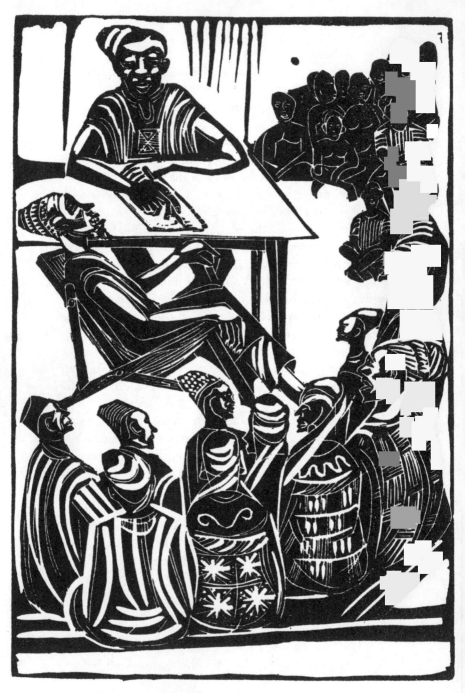

'My name is Akara-Ogun, Compound-of-Spells.'

you do. True, your wife ought to be beautiful lest you tire of each other quickly; and a lack of brains is not to be recommended since you must needs hold converse with each other, but this is not the heart of the matter. The important requisite is that your wife should not be prone to evil, for it is your wife who gives you meat and gives you drink and is admitted most to your secrets. God has created them such close creatures that there hardly exists any manner in which they cannot come at a man; and when I tell you what my father suffered at the hands of this wife of his, you will be truly terrified.

It happened one day that my father prepared himself and set off to hunt. After he had hunted a long while, he felt somewhat tired and sat on a tree stump to rest. He was not long seated when, happening to look up, he saw the ground in front of him begin to split and smoke pour upwards from the rent. In a moment the smoke had filled the entire area where my father sat so thickly that he could not see a thing; all about him had turned impenetrably black. Even as he began to seek a way of escape he observed that the smoke had begun to fuse together in one spot and, before he could so much as blink, it fused completely and a stocky being emerged sword in hand and came towards my father. My father took to his heels instantly but the man called on him to stop and began to address him thus:

'Can you not see that I am not of the human race? I arrived even today from the vault of the heavens and it was on your account that I am come hither, my purpose being to kill you. Run where you will this day; kill you I most resolutely will.'

When he had spoken thus, my father was truly afraid but even so he steeled his heart like a man and said, 'Truly, as I observe you, I know you are not of this world, and I see also that the sword in your hand spells

mortal danger for me. Nevertheless, I implore you, and I charge you in the name of the immortal God, do not fail to tell me the nature of my offence.'

The man replied to him, saying, 'Do you not know that you have grievously offended your Maker? That you have ruined his handiwork even to this extent, that you sent eleven souls to heaven when it was not yet the hour allotted them by their God?'

These words of his were a great astonishment to my father, for while it was true that he was well versed in magic and charms, he did no one any evil. So he replied to him, 'If this is indeed your complaint then your mission is to a different man; it certainly is not I. Since the day I was born I have never harmed anyone: I do not see a man going about his business and take umbrage at his existence; I do not see a rich man and suffer thereby from envy. When I see a man at his dinner I continue on my own way. I have never inflicted wounds on any man, I have not shot a man down in my life, so how can you claim my life, and for a crime of which I am innocent!'

He waited for my father to finish his speech and then he replied, 'True, you have not with your own hand killed anyone, but you have been responsible for the suffering of poor innocents. With your eyes wide open to what you did you married a deep-dyed witch for the mere beauty of her body — is that an act of goodness? Does the blood of your many wives not call out to you? Does the crime against your eight children not hang round your neck? And, despite all of this, do you have the gall to tell me that you have never been guilty of evil? Indeed there is no remedy; kill you I must.'

Only then did my father call to mind the kind of woman he had taken to wife, and so he replied to him, 'Truly I see now that I have sinned. I have a wife whom

I cannot control, I strut like a husband merely in name. What I should have done I have left undone, the path I should have trodden I have neglected, the creature who deserved to die at my hand I have indulged with praises. Ah, stranger from the dome of heaven, forgive me.'

When he heard this, the man forgave my father and desisted from killing him, but he warned him that he must, the moment he returned home, put my mother to death. So saying, he turned into the forest and continued his travels that way.

When he had gone my father took up his gun and returned home. And it so happened that the path he took led him past a field of okro on the way to the town. It was evening when he came there, the moon was already up, and, coming up to the field he looked over to the other side and observed someone approaching from that direction. Quickly he climbed up a tree, waiting to see what this person was about. The figure came on unswerving until it vanished into a large anthill. Shortly afterwards, an antelope emerged from this anthill, entered the field and began to feed on the okro. My father brought his gun to bear on the creature and drove furnaces into its skull. The gun had no sooner roared than there came from the antelope a human cry and the words, 'Ah, woe is me!'

That night my father slept in a little hut by the field. When daylight broke he went to the spot where the antelope was shot, but he found nothing there, only blood. He began to follow the trail of blood, and it was with increasing astonishment that he found that the trail led homewards. He followed it until he arrived right home. But in midtown the trail vanished completely and he did not come upon it again until he was nearly at his own doorstep: then it led him straight into my mother's room.

I had not myself slept at home that night. Whenever my father was away I hated to spend the night at home because the spirits gave one no peace all through the night. Even my mother rarely slept at home and then only when my father gave his permission. I returned to the house just as my father was opening the door to my mother's room, and when he had opened the door and we entered, that moment when I caught sight of my mother, it was all I could do not to take flight. From her head down to her shoulders was human enough, but the rest of her was wholly antelope. She was all covered in blood and swarms of flies. My father touched her; she was dead and had begun to rot. Indeed she was the antelope stealing out at night to feast in the field of okro.

And so did my mother die, and hardly was a month over when my father also followed her. From that day was I orphaned, fatherless and motherless. And thus ends the story of my parents and comes the turn of my own. I greet your labour my friend.

2

FIRST SOJOURN OF AKARA-OGUN
IN THE FOREST OF
A THOUSAND DAEMONS

The experiences which my father underwent proved to be nothing compared with mine. And when I go over it all in my mind, I am terrified to contemplate the case of those who are older, because if an old man began to recount all that had beset him on the path to the hoar on his head, many young men would pray for an early death.

By the time I was ten I had begun to accompany my father on his hunts and at fifteen I possessed my own gun. I was twenty-five when my father died, and, on his death, both the money he owned and the powers he possessed, all formed my legacy from him. Even before he died I had killed my first elephant, buffaloes had fallen at my hand, there were few animals in fact which my gun had not yet swallowed.

About the third month of my twenty-sixth year I seized my gun one afternoon and headed for Irunmale, the Forest of a Thousand Daemons. A huge forest is Irunmale, a full six hours from our town. The road to it is the same as that leading to Mount Langbodo, and that same road leads to the dome of heaven. There is no breed of animal missing in this forest we speak of; it is the home of every vicious beast on earth, and the dwelling of every kind of feathered freak. Ah, a most evil forest is the forest of a thousand daemons; it is the very abode of ghommids.

It was quite some time before I arrived at my

destination; night was falling, you could barely make out the lines on your palm. I was a little tired on arrival and could not even light my lamp for some night hunting. I made a fire in the hollow of a certain tree, took out a yam from my hunting-bag and began to roast it. After this I gathered up some fallen leaves and made a bed of them. My pillow served for a hunting-bag. I primed my gun soundly and placed it next to my head. That chore completed, I stretched out on my back and went off to sleep.

I had not slept very long when I awakened, and indeed it was the cries of ghommids coming to trade at the night market that woke me. For while it is true that they emerge both day and night from this forest, yet it is only at night that they conduct their business, and it is at night also that they bring all petitions forward to their king who is known as Olori-igbo, Lord of the Forests. With pity for myself do I tell you now that that very tree underneath which I had elected to build my fire was the abode of their king. Even up till the moment when I went off to sleep I had guessed nothing of this, and it was only when I woke up and heard the sales cries of the ghommids that I was smitten with fear, and, quickly seizing my gun and securing it across my shoulders, I hung my bag around my neck, caught hold of a creeper and climbed into the tree, little dreaming that it was the head of the king of ghommids himself on which I now chose to sport. Thus it was that I proceeded to add insult to injury; that I had camped at his feet was not enough, I had to climb the head of the unoffending man.

Some time went by after I had climbed to the distant treetops, and then the court nobility began to arrive. A huge fire leapt up from some quarter and the entire surround of the tree was lit up brightly. As the

ghommids arrived they sat round the tree; they were all of a great variety, like the clothing of *alagemo* — some walked on their heads, others hopped frogwise, one had neither arms nor legs; his appearance was like a rubbery tub. Last of all came the king's crier and he began his summons thus:

'Lord of Forests! Lord of Forests! you are the merchant prince of ghommids; I say you are the merchant prince of ghommids; there is no trader to equal you. The arm of the human kind accompanies the pounded yam when you dine, their fleshy breast provides the meat for your *eba*; when you drink corn pap, their skull serves you for a cup — what, I ask, can a son of man do to you? Forest Lord! Have you lately taken to walking on your head? I say have you now taken to walking on your head? For your eyes are now where your buttocks should be, spitting embers. Forest Leader, are you feeling tired? For why else have you not yet emerged? We are all assembled and still await you.'

When he was done, the Forest Lord himself raised his voice in a huge bellow. His voice totally encompassed the forest, the beasts of the forest were hushed, sleeping birds were wakened in their nests, fishes fled to the depths of the ocean, and all the leaves in the forest bowed in reverence. Not one thing rasped against the other, the lips of the forest were sealed in silence. The voice cried, E-e-e-e-e . . . eh! E-e-e-e-e . . . eh! That fire at my feet is the handiwork of man. Your Forest Lord cannot come out today, do you not see that dumbbelly object dangling from my neck?'

When he had spoken thus, they all looked up and saw me. A-ah, the dance-prone danced, the joy-filled rejoiced, they began to count their chickens for they looked forward to killing and feasting on me. Even as they began to plan how best to pluck me down, I

remembered an appropriate spell, *egbe*, the rarifier. Quickly, I invoked its powers and at once I found myself back in my own room, snatched thither by *egbe*.

When I had rested awhile and regained my composure, when I saw that I was truly back in my own room, I felt ashamed and said to myself, 'Is this not indeed matter for shame? I call myself a hunter, yet on my very first outing after my father's death I am forced to flee home in this manner! I who affect the name of hunter! No! Sooner death than this disgrace. I shall return to that forest—is not my name Compound-of-Spells? The witch who seeks to devour me will find her teeth all dropping off, the sorcerer who dares to look me in the eye will provide the next meal for my gun, any ghommid who wants to test the keenness of my sword will lose a hand in the encounter. The hand which takes food to the mouth always returns. The King of Heaven will surely see me return home safely!'

So saying, I repeated my incantations and commanded *egbe* to return me, but instead of landing me on that former tree, I found myself complete with gun on a palm tree, punctured by a hundred spikes. And as if that was not enough it began to rain; it beat down on me so heavily that I was well nigh deaf and it did not stop until near daybreak. When it was finally spent I came down from the tree, rescued my matches from where I had protected them from the rain, made a fire at the base of the palm, took off my upper clothing and spread it near the fire to dry. Before long it dried, so I took off my trousers also and dried them. After this, I took out a little yam, roasted and ate it. When that meal was finished I stuck my pipe in my mouth and lit it; the smoke fanned out smoothly—I was a much contented man.

As I sat puffing at my pipe and enjoying myself, I

heard a voice raised in loud grumbling close to a walnut tree some distance away. I raised my head in that direction and saw a huge swarthy man who kept up a stream of moaning: 'These stink-bugs are at work again, they simply will not give a man some rest.' I did not so much as give him a second glance, I merely intensified my smoking. I had recognised him, he was a walnut troll and it was my tobacco which gave him such offence — ghommids do not take at all kindly to unpleasant smells. When I saw that he persisted in his grumbling, I turned in his direction and proceeded to smoke him out; this only made him more furious and he became really abusive:

'Fathead, stinking corpse, when you wake you don't wash, when you excrete you don't clean your anus, every pore in the body oozes some smell, the entire spine is caked with dirt.'

When I heard this I grew angry in turn, I faced him squarely and said:

'And do you have the nerve to revile anyone in this world! You soot-grimy creature, you dead and bloated toad, if you don't watch out where you stand I'll blaze fire-tracks through your skull this instant.' When he heard this he said not another word; he merely turned his back on me, hissing contemptuously as he walked away.

It did surprise me that heavy as the downpour was during the night, the sun came out fully in the morning and shone throughout the entire day. As it grew near the hour for a morning snack, I picked up my gun, shouldered my hunting-bag and went after game. I walked for a *long time* without bagging anything; I did not even see any game at all, only heard the voices of birds. It turned out simply that I had not yet arrived at the real haunt of the animals. Some time later I came

there; my heart leapt when I saw these creatures disporting themselves and I sat and primed my gun. Afterwards I rose, cut a branch and stuck it in my mouth for camouflage and hid by the bole of a tree, waiting. At the moment when I had a really good chance to make a kill a singular being appeared, hardly taller than my waist. He had a small mat under his arm and wailed aloud. As he wailed tears fell from his eyes, his nostrils dripped mucus and his lamentations drove the animals away. At first I hoped his clamour would soon cease but he showed no signs of stopping. He would weep for a while, then let out a tremendous cry and all the animals would take to their heels. After a while I could not bear it any longer, I came out and faced him directly, saying in great anger, 'What a rotten race you ghommids are, you who drip incessantly from the nostrils! Just what precisely is the cause of your tragedy? What anyway does a thing like you want with a mat? If you don't shut your mouth this instant I'll shoot you where you stand.'

He heard me to the end, then looked at me as if I mattered less to him than a speck of dust. He eyed me meanly for a while and then said, 'Even so do you children of earth behave, you who have turned kindness sour to the charitable. We watch you, you whose eyes do not stay long in one place, you who chase emptiness all your life. Those who already boast a full stomach continue to seek glorified positions, seek to live like kings, forgetting that the fingers of the hand are unequal. And it is also in your nature that your minds are never at peace; those who find happiness today ensure that their neighbours find no peace the day following; death today, tomorrow disease; war today, confusion tomorrow; tears today, tomorrow sorrow — such is the common pursuit of you children of earth. And when

we think of your plight, we pity you, we weep for you and drip at the nostrils, but instead of earning your affection, instead of you dancing to greet us and fussing over us, you find even our mats a cause to despise us, our running nostrils become your favourite target, you speak of our solicitude as a punishment, our existence as beneath contempt—even to the extent that you have now coined the belittling expression, "Tears in the eye of a gnom."'

Let me not lie to you, I was somewhat ashamed listening to the words of this creature, for all his insults on mankind were well observed. However, inasmuch as I did not want him to realise how his words had hurt me deep inside, I burst out laughing and assured him that I was only teasing him anyway. He thereupon resumed his lamentations and went on his way. He had taken a few steps when I thought to myself, 'A man mends his fate with his own hands, why do I not crave a boon from this creature?' So I called him back, prostrated myself full length on the ground and begged him to grant me a boon. He was very pleased that I had acted in this manner and he gave me four pods of alligator pepper; he gave them to me in two pairs and instructed me that in time of danger I should eat a single pepper from one of the first pair of pods, whereupon I would grow wings and fly like a bird. And the moment I wished to retract the wings, one pepper from the other two pods would produce the desired result. When I tried out this formula, it proved a sure-fire treatment.

After he had passed on this gift, he went his way and I turned into the forest, seeking game. I walked some distance and the animals leapt about while I sought my chance to take careful aim. And yet again I came upon another abbreviated creature driving away the game. He was shorter still than the one I had met

before and his entire body was uncompromisingly black. Once again I grew infuriated and spoke fiery words to him: 'You are wicked creatures, you ghommids, pitiless as well, and that is probably why your growth is stunted since you are occupied with nothing but pointless acts. Game there is and in abundance but you do not hunt it, yet you will not let others alone to hunt.'

When I had thus berated him, he levelled me to the dust with one long look, hissed in contempt and began to speak:

'I am the Crown Prince of Forests, the bog-troll who lives in crevices of the mahogany. Have you never heard of me? Know you not that earthly beings dare not disrespect my person? That a mere son of man dare not affront my presence? It is lucky for you that I take pity on you or I would assuredly reveal to you that this forest in which you hunt is indeed the Forest of a Thousand Daemons. Diminutive though I appear, I pursue the task which my Creator has assigned to me: I walk the walk of the wise, I act with the nature of the discerning. I never reach for that which my hand cannot encompass, nor do I embark upon that which is beyond my power; I do not act in the manner of the thoughtless, nor do I complete an action which I then regret. I proceed along the course which I have set for myself, and pursue the task I have set my hand upon since the day of my creation by God the King. You arrogant creatures, you who throw good money into the gutter, you tell yourselves that you are buying clothes and waste your money because of the superficial pleasures of life. You want to live up to worldly expectations, so you attempt things which are beyond your powers, you forget that the tongue of men is merely slick, that a man they malign today they are quite likely

to praise tomorrow. When a man makes an effort at something, the sons of men sneer at him, but when success has crowned his efforts they turn round and hail him. There is no one immune from their calumny. They malign the poor and malign the rich; they malign the common man and malign the famous: when they feel like it they malign their king also. Therefore, continue on your way, and I also will follow mine. I merely go where my Creator has sent me.'

And thus he had his say and went his way. I was now thoroughly fed up with the whole business; every ghommid alike appeared to use me ill. After this one had gone, I began to sense the approach of game, leaping from tree to tree. Investigating, I found it was a brown and white-patch monkey. A shot bagged me the monkey, I tucked it in my bag, tossed it onto my head, and, gun on shoulder, directed my legs to my rude hunting-lodge at the base of the palm tree.

On arriving there, I took up my knife and skinned it, built a little truss no higher than my knee, stacked a fire beneath, piled my venison on top of it and fired it. That which I did not pile on the truss, the scraps and tit-bits, I began to roast in the fire, eating them on the spot. Highly enjoyable they were too for the meat of the monkey oozes delicious juices.

Not long afterwards, it darkened, and towards the eighth hour of the evening I lit my hunting-lamp and began to seek game. I did not search very far before my eyes fastened on another pair of eyes belonging to some creature, gleaming a short way from me. I shot and killed it and it turned out to be a civet. I took it to my camp, skinned and carved it, piled the pieces beside the monkey and cracked the fire up at them. I did not trouble to hunt any more that night, and when I had tended the civet, I lowered my back to the earth

and dropped off to sleep, and it was not till the cooing of the cuckoo that I awoke the following morning.

On the dawning of the next day therefore—and this was the third day of my sojourn in the Forest of Irunmale—I ate, filled up properly so that my belly protruberated most roundly. I reached for my gun, primed it diligently, seized my hunting-bag, slung it over my shoulder and so into the forest. It grieves me to admit that I had out-eaten remembrance of those charms which I should have taken with me. I left them at the foot of the palm and took nothing but the shot for my gun, and my cutlass.

I had not walked very far before I began to encounter game, but they would not be patient and persisted in running pointlessly about. And just when an opportunity presented itself for a shot, I heard a rumble as of six hefty men approaching; indeed, it was no less a monster than the sixteen-eyed dewild; often had I listened to hunters recount tales of him—Agbako, that is his name.

When I set eyes on him, I was—unless I lie in this matter—smitten with terror. He wore a cap of iron, a coat of brass, and on his loins were leather shorts. His knees right down to his feet appeared to be palm leaves; from his navel to the bulge of his buttocks, metal network; and there was no creature on earth which had not found a home in this netting which even embraced a live snake among its links, darting out its tongue as Agbako trod the earth.

His head was long and large, the sixteen eyes being arranged around the base of his head, and there was no living man who could stare into those eyes without trembling, they rolled endlessly round like the face of a clock. His head was matted with hair, black as the hearth and very long. Often swishing his hips as he

swung his legs, Agbako held two clubs in his hand and three swords reposed in his sheath. A very evil spirit was Agbako.

As soon as he spied me, he made my person his goal, treading the earth with purpose. And when I felt that he had come close enough, I ordered the road to seize him and it seized him and cast him in the bush. But even as the road obeyed me, so did it heave me also, and I found myself right in front of Agbako. I was terrified and conjured earth to return me to the road, and so it did. But even as I emerged on the road, who should await me there but Agbako! This time I invoked *ogede* and commanded the road to return him to the bush where the ropes of the forest would bind him. And the road obeyed and the forest bound him.

But just as he was flung into the bush even so I was served, and I found myself face to face with him and the ropes began to bind me. When the thongs began to strangle, I yelled on the forest to release me and set me back on the road. It obeyed. Needless to say, Agbako was there to welcome me. So, seeing how things stood, I prepared for fight and we joined in a death grapple. We fought for long but neither toppled the other. We were smothered wholly in sweat, my eyes were reddened and, as for Agbako, his eye-balls were as blood-drops. The ground on which we fought shone like glazing.

Later, I tired, but not he. I untwined my arms but he held fast to me. But when he perceived himself that I was too exhausted, he released me. Dipping into his pouch, he brought forth a gourdlet, and when he had walloped it hard, it turned into a keg of palm-wine. Agbako sat him down and began to serve me, and he refreshed himself also. When the keg of palm-wine was depleted by half and I had rested somewhat,

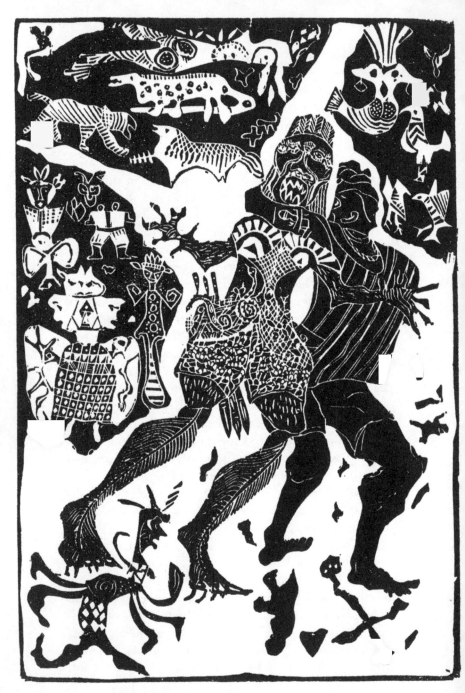

'I bulled into Agbako and seized him by the neck.'

he suggested that we had drunk enough and that we should resume our strife. This we did forthwith.

We had been wrestling awhile when I retreated a little and drew my cutlass and, even as he began to draw his, I slipped behind him and slammed him one on the back of his head. But it was my cutlass which broke in two, one half flirriting off, while he wasn't dented one bit. Then he turned from me, picked up the truant part of my weapon and, taking the stump from me, joined them together so that the break vanished completely and the cutlass was as before. And he said we should continue with the fight. And now I was truly exhausted; my breath came and went in rapid bloats like the hawing of a toad. Just the same I continued the fight and, lifting my cutlass, brought it down hard on his side. Before I could retract the blow, he in turn slashed me on the sword-hand, cutting it off cutlass and all. I followed my buttocks to the ground, wallowing in the throes of death.

Even while I groaned in pain, Agbako again took my missing arm, fitted it on the stump, spat on his hand, and when he had rubbed the spittle on the join, my arm returned to normal and I could not believe that anything had happened to it. Then he looked at me and, bursting into laughter, declared that we must continue the contest. My terror was now complete and I said to myself, E-ya! Is this not the certain approach of the end? So I cried aloud: 'Spirits of the woods! Pilgrims of the road! — hasten to my rescue!'

And shortly after, every being in the Forest of Irunmale came, the ghommids on one side, the birds on one side, the animals separately, but Agbako gave no sign that he saw anyone. He pulled me from the ground and we grappled anew. If I swayed him he swayed me, if I threw him he threw me. The fight was

long and fierce. Every leaf was stilled and the forest lulled in silence.

The ghommids had been watching us for a while when I saw one of them detach himself from the rest and come to the scene of struggle. He signed to Agbako to release me, and Agbako complied. Then he offered me a slice of kola-nut which I took and ate. And instantly a new vitality flooded me and my strength became the strength of sixteen men. I bulled into Agbako and seized him by the neck, when I had squeezed it hard he bellowed like a beast and all the ghommids cheered.

But when I tried to lift him from the ground and smash him in the fatal throw, his foot did not even turn aside; firm he was as a lode in a crag. And he in turn strove to lift my leg to his shoulder, slap off the other foot and paste my marrow on the ground, but he failed in this and I stood robustified. He fisted me and I felt it not, he kicked me but he did not triumph; then he turned scorching hot from his head to his toes, and the breath of his nostrils was like a violent storm.

And then it was that he slarruped sparks ablaze in my face, proving to me that he was indeed Agbako the Master. He thudded earth with his feet and the earth opened beneath us and Agbako and I were sucked into the void.

When I arrived at the interior of earth, I found myself in a strange house. Of Agbako there was no sign, and until my return from this trip I did not set eyes on Agbako again. Not until the day of our journey to Mount Langbodo was I to encounter him again — you will hear about this later — but what I experienced until my escape from the depths of earth I will never forget in this lifetime, and when I am gone to heaven I will remember it all, even there, for ever and ever.

The house in which I found myself was of modest

size, cowdung was used in plastering the floor and the walls also, but the ceiling was lined entirely with guns. There was neither window nor door, yet the house was full of light; where this light came from remained a puzzle. I first discovered myself right in the centre of the room, and even as I stood inspecting my prison, I saw the four walls of the house coming towards me, so that the room became progressively smaller as if the walls planned to squeeze me to death. I was most afraid, but when it lacked only a little for them to come to grips with my body, they returned to their position and the house was as before. And just as they regained this position and my heart began to settle back, the armoury of the ceiling began to fire, the house began to shake and I felt I was about to fall; disorientation became my lot like the monologue of a gnom. I stumbled here and there, fell, and settled on all fours. I was in this position when my eyes went blind and I felt hands begin to touch me: it was a very cold touch. After a while these people began to dance round me, clapping their hands above my head; I heard their footsteps distinctly, as the footsteps of a hundred people. They did not stay doing this for very long before they seized me and began to toss me up, catch and toss me up again. Not long afterwards they set my feet to the ground and began to undress me and place different clothing on me, laughing all the while. Then one rubbed his hand over my face and I regained my sight, but when I looked round I saw no one; I found myself on a large chair, my size was enormous and I was covered in feathers. I had grown in size, but my entire body was not uniformly increased; my arms had not changed, my legs had neither lengthened nor thickened, but my belly was twelve times distended and my head sixteen times its normal size. My neck was not much thicker but was

stretched beyond imagination. I was highly amused when I beheld myself, and there was no choice but to sit quietly. I did not rise for fear that my legs would not support my stomach, for even as I sat my head became a heavy burden on my neck; there was simply no strength to the neck.

Some time went by and I began to feel hungry. Even as I began to consider how I might find some way to a little food, I saw in front of me two balls of *eko* and meat stew. I tried to edge closer to start my meal but I soon discovered that my stomach permitted no approach to the food; it had taken up the entire room. As I began to manoeuvre towards this food, I was astonished to see it come towards me, and soon enough it settled where my hand could reach it. I took a morsel and accompanied it mouthwards but, alas, I found only then that my hand no longer came up to my mouth. My neck was excessively elongated, it more resembled a heron's, and its bone was hard as rock so that it could not be bent. Anyone who wants a laugh should have come and seen me struggling to lead some food into my mouth. Whenever it lacked only little for the morsel to touch my lips the arm would reach its limit, and when I tried forcibly to propel the morsel to its destination oil flowed down my hands and my neck was full of food crumbs.

Listen, my good friend, the soul which does not eat hot peppers is a weak soul; I *love* food, I simply cannot endure hunger. Because of this I was known to many people as 'Akara-ogun, the one who accompanies the cook to the grave'. This nickname of mine will give you some idea how my innermost being craved this food. Even as I continued the struggle I saw a small flat stick nearby, reached gingerly for it, dug it into the *eko* and began to convey some food to my mouth. The quantity

lifted by the stick was far larger than my mouth could admit for my mouth had not increased its former size, and when this huge lump of *eko* landed just inside my lips it blocked my mouth entirely, and as I strove to eat down the inside portion so as to attack the outside, that portion fell away from my mouth. Even so did I vainly struggle, and I could not enjoy my meal.

From the moment I began this effort to eat I had heard voices laughing quite close to me, but I did not see anyone. When I had done my best and eaten next to nothing, I cried to them:

'You who laugh over there, I implore you in the name of God, if it was you who changed me into what I am this moment, do not fail to return me to what I was before. It was ignorance which led me to fight with Agbako; never again will I attempt such folly. If I hear news of Agbako's approach in future I will learn to start a rapid dialogue with my legs and ram my head through forests. I appeal to you, kindly release me.'

When I had spoken thus, they remained silent. After a while, my stomach began to retract, my head diminished, my neck shortened and soon every part returned to normal. From the moment I returned to my normal shape I no longer heard a sound from these ghommids, but the house did not cease to behave in its original manner, and, anyway, I did not discover a means of escape. Some time passed towards nightfall, and then I saw a wall of the house split in two and a beautiful woman came in with a number of young maidens, several of them and all more beautiful than coral. I was smitten with fear at the sight of them and I threw myself face downwards on the floor. But the woman came to me and said:

'Akara-ogun, you are aware that even as dewilds exist on this earth, so do spirits exist also; even as

spirits exist so also do kobolds; as kobolds on this earth, so are gnoms; as gnoms so also exist the dead. These ghommids and trolls together make up the entire thousand and one daemons who exist upon earth. I am one of them, and Helpmeet is my name. I love the Lord and he loves me also; he has never denied me aught, nor have I ever failed to perform an errand on which he has sent me. Thrice in one day I go through the world to visit the friends of God and to assist them in all their endeavours; whoever bears only a little love to Him, I perform a little service for him; and he who loves my God with a great love I care for in as great a proportion; whoever acts with concern towards Him I treat with concern, and whoever treats Him with disrespect even so do I act towards him; for whoever sows well shall harvest goodness, and whoever sows evil, evil shall come unto him. The truthful shall not fail to profit good, the deceitful shall gain nothing but deceit; even if it came to pass that the world turned topsy-turvy, that fowls grew teeth and the oil palm grew coconuts, God will not fail to reward every man according to his deeds. So now, you Akara-ogun, rise and follow me, for you are a most important instrument for your Creator.'

When she had finished, I rose and followed her, and we emerged from this house into a certain bush and so continued our progress. We traversed valleys and traversed hills; we crept under creepers and waded through swamps. After a while we arrived at a crossroads where she stopped and showed me a route, saying:

'Go on now and pay attention to the things you shall witness in this city; never fear and be not cowed by terror, my name is Helpmeet, I will never desert you on this earth.'

After which, I set my head along that road, and she also went her way. I walked a little while and arrived at a certain city. From my entry through the city gates until I arrived at the market square—this was roughly ten minutes—I heard not a single voice even though I encountered many people, and when I called out greetings to them they would merely mumble in their noses nor did I understand one word they mumbled. When I arrived at their market I stood by a certain tree and began to watch.

What amazed me most of all in this market was that many children were dead in it yet no one made any attempt to bury them. Corpses littered the place in prodigious numbers, the entire market stank and flies swarmed over it with an incessant buzz. I waited a little and then I saw a woman approach and greet me. This made me happy and I responded eagerly; I then went on to tell her how astonishing a matter I found it that no one spoke at all among these market crowds, that they should all merely mumble, and although I had greeted many of them whom I encountered not one of them deigned to respond to my greeting.

When I had had my say she looked at me and grew distressed, saying:

'My name is Iwapele and the name of this city is Filth. It is a place of suffering and contempt, a city of greed and contumely, a city of envy and of thievery, a city of fights and wrangles, a city of death and diseases—a veritable city of sinners. Once upon a time, the people of this city committed a most atrocious crime; a very evil deed it was—so evil that the sun did not shine for six entire months, nor did the moon emerge for three whole years; the rain fell no more and the corn did not come to fruit, the yam did not sprout and plantains refused to ripen; everything was in utter

confusion. After a while, however, God took pity on the inhabitants of the town; he remembered that these people were after all his own creation; he forgave them but warned them never to repeat their offences, and everything returned to its previous good. But when they had again eaten well and drunk to satisfaction, they forgot who made them; they began to walk in the path of their own choosing and to act in any manner that pleased them. But their Maker saw them from heaven, for all acts of mankind are observed by God and there is nothing hidden from Him. Therefore He sent his emissaries to enquire into the misdeeds of this city of blood; they came in the guise of men and they lodged at my house. I took good care of them and honoured them; I welcomed them hands and feet, took such care of them as was within my power. They did not stay long with me, only long enough to deliver their message from the King of Heaven. They turned the dwellers of this town into a race of the dumb and punished them all with blindness; the city became a city of curses for ever, but I was spared by God. Now that I have set eyes on you I do not want you ever to depart from me. I want you to dwell with me that I may hold converse with you and you with me, for it is the company of the open that the open keeps, it is the company of the masquerade that the masquerader seeks, the fish swims after the company of fishes in the river; you are of my own kind.'

When she had finished I replied that I would do exactly as she counselled for I was tired of so much aimless wandering. But I sought her indulgence to stay a little and observe the events in this market before we went on to her home. It was only after her speech that I realised that these people were all blind and dumb, and the factor which had made me unsuspecting was

that their eyes were wide open as if they could see; little did I know that the eyes which they carried about with them were eyes of deceit.

Many, many things did my eyes behold but I will not state them all now, I will recount them another day. Nevertheless I will tell you a little of them lest it appear that I skip over this episode entirely.

The first incident I saw concerned a certain man, a cripple, who walked with the aid of a crutch. This man went very fast and hopped about on his staff, and he soon bounded past me in the direction of a pond. Seeing how close he was to it, I cried a warning to him that his course was no thoroughfare but he paid no heed. On arriving at the edge he leapt straight into the pond. He was thoroughly soaked and I found myself full of pity for him. But instead of distress, this man simply burst into laughter; he emerged from the pond and continued his mad dash all over the place. He had not hopped more than three times when he leapt against a woman. This woman was enraged but as she lifted her arm to strike the offending man, it was a totally different person whom the arm encountered and he in turn grew wrathful. He raised his hand in vengeance but administered the punishment to yet another man. Before long the fight spread to the entire market crowd and they began to strike one another. As they rushed here and there several babies fell off their mothers' backs and it was over their heads that the combatants charged to meet one another. In the same manner the aged among them who had little strength to prop them up fell and could not rise, while the entire populace made their bodies their thoroughfare. Often when a baby had fallen down on the battleground and the mother stooped to pick it up, instead of hers she picked up another's; some picked up dead babies

instead of their own living children, for God was full of anger against them.

One other thing I observed was that many of them wore their clothes inside out; some wore their *agbada* back to front, some among the women wore their head-ties inside out; every garment shone with filth, it was more like the inside of a hunter's bag.

Many sights did I witness in this market but they are far beyond what I can narrate at this time. When I had stayed awhile and had seen enough I followed this woman to her home and we began to live together.

I went often to their law courts. At times when a man had committed an offence and they sought to punish him, the policeman would seize one of the nobility, and before he discovered the victim's true identity, would have served him many slaps in rapid succession; at times when the king tried to mount his horse he landed on a cow; even so did the affairs of these people run higgledy-piggledy, topsy-turvy.

From the day of my arrival in this town there had been a room in the house where I lived which the woman, my host, would never allow me to enter. She had, shortly after my arrival, asked me never to go into that room as long as she was alive, but that after her death I could do whatever I pleased for the entire house would then be mine. The woman and I loved each other greatly; it was a great love and I began to consider seriously taking her to wife; and it was at this very time that she was laid prostrate by a sudden illness, and in the course of this illness that she died.

I had not thought that this woman would die before me, for I was by far the elder; only when she had thus died did I acknowledge that children and aged alike, none can escape the hand of death. After her death I wept till I nearly went blind, forgetting that

weeping does not bring the dead back to life, but only puts the living in peril. Let the wailer weep eternally and the sighing sigh for ever, he who must cannot help his going.

After the woman's death, I began to seek some way of escaping from this town and, as I sat down one day thinking how I should proceed, my mind went to the room which the woman had forbidden me to enter. I rose from the ground, put on my clothes and headed for this room as I wanted to see what it contained. On the point of opening the door, I was at first afraid, but when I recalled how much I had undergone in the past I said to myself that I simply had to open it; whatever would come of it, let it come: and so I threw it open. The very instant I entered the room, I found myself in my own room at home, and when I looked round I found my gun which I had lost at the place where I did battle with Agbako; I found my hunting-bag and a few other articles which I had lost in the Forest of a Thousand Daemons and when I looked into the corners of the room, I discovered a bag of money.

I spent this money in pleasures on myself, I ate, drank, draped myself in decent clothing.

Thus ends the story of my first sojourn in this most terrifying forest. I would now like you to find me a little food for hunger is at hand. When I have done with eating I will lay my tongue to the tale of my second journey, and that story is even more delectable than the one that has gone before.

❀ ❀ ❀

Even so did this man narrate the adventures of his first journey to the Forest of a Thousand Daemons. When his tale was ended I brought him food and he ate, but

I saw that night was approaching, so I suggested that he retire for the day and return at break of the following day. I accompanied him some of the way and we exchanged farewells, 'Till tomorrow.'

3

SECOND SOJOURN OF
AKARA-OGUN IN THE FOREST
OF A THOUSAND DAEMONS

WHEN the man had departed and I had returned
home I called my neighbours together; I summoned
friends and acquaintances, sent for my relations also
and recounted this affair to them. They were greatly
amazed and all resolved to wake early the follow-
ing morning before my stranger arrived, so that they
might themselves listen to the man's adventures, for
my re-telling could not aspire to their own participa-
tion. True enough, sharp on the moment the new day
began to break, they began to arrive, and by the time
that the man himself entered my house it was filled to
overflowing and could hardly take another pair of feet.
Before dawn I had ordered my servants to prepare
food, and so before the stranger began his tale I placed
before my guests four baskets of *eko* and ladled meat
into dishes for them. Each and every man of us ate to
satisfaction and drank, after which the stranger rose
and began to speak as follows:

I am happy to see you all, friends, sitting here —
young and old, male and female. Were it not for the
great affection you bear my friend, I would not find
you here. When I came yesterday I did not meet any
one of you, there was only this friend of mine. He bade
me welcome, took good care of me, and behaved to-
wards me with the nature of courtesy itself. My prayer

therefore is, may God let this kind of conduct remain among us black races for ever.

Without a doubt, my friend has told you the tale about my parents, and about the various things which I experienced when I visited the Forest of Irunmale. And I think I do not lie when I say that anyone who has listened to these adventures could not fail to believe that I would never dream of hunting again. But no, I did hunt again, for it is in the profession to which a man is trained that he must serve; the goods which he truly understands are what a trader sells, and it was not fitting that I should leave my profession at the prime of day and turn to masonry or wood-carving. But certain it is also that, if you learnt that I had indeed returned to hunting, you could hardly imagine that I would return to the Forest of a Thousand Daemons. I wish to let you know that it was to this very place that I turned myself. He who must do what no one has done before him will experience that which no man has experienced before. No hunter makes a habit of exploring the Forest of Irunmale as I did, no hunter undergoes such punishment as came to me. I endured plenty; and even so should it be with me, for there is truth in this saying of our elders — The aggressive man dies the death of war, the swimmer dies the death of water, the vainglorious dies the death of women; it is the trade of the cutlass that breaks its teeth, the food we eat is what fills our bellies — may God forbid that what you eat bring about your death.

A clear year after my return from the first adventure, I once again took hold of my gun one night and set my head on the road to the Forest of Irunmale, all eager to do some hunting. When I left home I had imagined that it was on the verge of dawn, but the truth was that I had set out in the very dead of night;

the brilliant dawn-lingering phase of the moon had deceived me into thinking that a new day was about to break. However, by the time a man could begin to distinguish the lines on his palm, it lacked only two hours for me to arrive at my destination. It was a different route which I took to the Forest this time. I did not wish to return the former way lest it appear that I sought out trouble with my own hands and met the consequent misadventures, that I pulled the whirlwind down on my own head.

I arrived finally just about breakfast time; quickly I made a fire and roasted a piece of soft yam. My meal over I tucked my pipe into my mouth and lit it; my body was filled with pleasure and tingled all over with well-being. After a while I put out my pipe and replaced it in my pocket. When I looked up I found two kolanut trees, one had no fruits but the other had some. I plucked the fruits of the latter and found three pods. When I had split them all open the nuts numbered ten. I took the largest of them and peeled it, its skin was wafer dry; I broke it open and it pared in four. So, since this variety of kolanut is excellent for ritual offering to the gun, I propped up my gun and offered the kola. But when I cast the pieces, the result was inauspicious. For if it spoke good, would two pieces not face down and the other two up? Alas it was not so for me, sometimes three pieces faced down and one up, and at other times all four faced down — the matter of this kolanut was simply beyond my comprehension. So when I had cast them many times without good augury, with my own hands I turned two up and faced two down saying, 'With his own two hands does a man mend his fortune; if you kola pieces will not predict good, I will predict that good for you.' After I was done I picked up my gun and proceeded to the forest of game.

Even as I stood up, I stubbed my left foot; this was my maternal foot and whenever I stumbled by this foot over any matter, that affair would not prosper. This frightened me somewhat, and while I stood pondering on this unlucky foot an owl flew past and its wings hit me in the face; a most evil omen was this. I stood for nearly ten minutes thinking about these ominous signs but in the end I simply bartered death away saying, 'What of it! Does a man die more than once? If death must take me then let me get on my way.' I plunged into this forest and began to seek game. After a long while I saw an antelope, with its haunches turned to me. I waited some time for the creature to turn its head towards me but it did not oblige; thereupon I loosed a shot at it. The animal was hit but the shot was not lethal. It leapt into a zig-zag flight and I in turn seized my cutlass and gun and chased it. I chased it over a long distance but did not catch up with it; after a while it fled into a cave within a large rock and I followed it inside.

The cave was large and exceedingly dark; from the moment I entered it I no longer saw the antelope, I could only follow the thud of its hooves. But after a while there came the moment when I neither saw the antelope nor heard its hooves. It puzzled me how it could have vanished in the middle of this place and I began to hunt it everywhere. I was occupied with this when I suddenly felt someone seize me by the right hand, twist the arm behind my back and fetch me a slap on the ear. This person's hand had a severe sting to it; even as I struggled to free myself from his grip he used his left hand to grip me by the neck and, when he had squeezed it tight, began to push me forward with regular shoves, slapping me as we went along. When, after some time, the punishment became unbearable I

began to cry out, 'Please let me go, I will never again touch your antelope. Please, I will never again kill your game. . .' But he made no reply; he continued to shove me along and punish me as he went. Sometimes he would pinch me, other times he would rap me on the head; there was no variety of torment he did not devise for me and I could not even see him because it was pitch dark. It seemed a long time before we emerged in the open, and only then did I observe the man; he was not much above short and his back had an enormous hunch, fins covered his body so that it had the appearance of a fish. He had two arms, two legs, and two eyes like a human being, but he had a small tail at his posterior and his eyes were enormous; each one was six times the normal size and red as palm kernels. When we came out into the open he ordered me to stoop and place my hands on my knees and I obeyed him. When he observed that I had done so he mounted my back, kicked me and ordered me to bear him about as if I was a horse. Like it or not I had to do this also. I want you to know that he had seized my gun before we came out of the cave, and when he was astride my back it was he who held on to it.

We emerged into tall grass and it was here that my torment was most severe. Before he climbed on my back he had cut several switches and kept them by him, and from the moment he spurred me and turned my head in the direction of his choice he began to laugh and to drip saliva on my head; whenever I tried and sought to raise my head a little he would lay about me with the whips and I would at once resume the race. Sometimes he would ask me to neigh like a horse and when my voice did not simulate a horse's satisfactorily he would blast my ears with several slaps. Sometimes he demanded that I toss him up and down like a

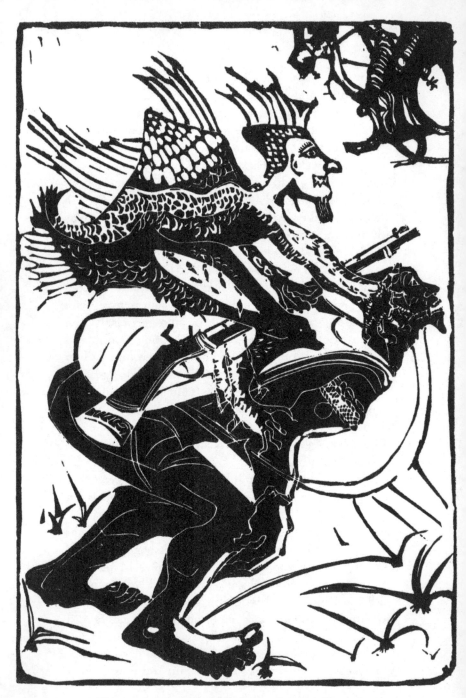

'He mounted my back, kicked me and ordered me to bear him about as if I was a horse.'

horse, and there was no remedy but to obey him; if I did not he would thrash the very breath out of me. It was during these riding sessions that we arrived at a spot where there was a large hole. He dismounted and took a thick rope, tied my hands together behind me, then entered deeper into this hole and returned with a large chain which he hooked round my neck. He did not make it too tight but slackened it a little so that I was able to breathe comfortably. He then tied the chain to a tree and returned into the cave; this was the home of the creature.

It would be about two o'clock when we came to this man's dwelling, and when I saw that he was safely in, I took hold of tears and began to weep them. I was careful to cry very softly lest, overhearing me, he return to punish me even more. About half past four, the man came out from the cave and approached me; he pressed on my stomach to see if I was hungry and when he observed that my stomach was little better than flat he returned into the cave and brought out a raw, uncooked yam, cut pieces into a leaf and placed it before me. He put it down and told me to kneel and eat it directly with my mouth. I tried a little of this yam but my throat was not too favourable towards it, so I left the rest alone. His next act was to loosen the chain from my neck, untie my arms and mount again on my back, and I began to bear him round and round in this bush. It was about seven in the evening before we returned to his home and on our return he himself ate some of the yam that I had left uneaten, and I ate the rest. Afterwards he secured me as before, re-entered the cave, and slept.

As you will surely realise, I did not sleep till daybreak. I was full of doleful thoughts and frequently sobbed aloud. The following morning my captor fed

me on raw yams as on the previous day and again I galloped him around till nightfall of that day; at evening we returned to his cave and once more he chained me by the neck to a tree, and when he had fed me on raw yams, re-entered his home and slept.

You will be thinking by now that I ought somehow to have freed myself during this length of time—and rightly too. What made the situation so dismal was that he had seized my gun from the moment of my capture and when he arrived home he took it into the cave; he even took my hunting-bag at the same time. And from the day that I came to that place, he never allowed me to enter his home: whenever we returned to the cave, it was the chain for me. I tried the few spells and charms which I had left on my person but none of them had any effect. I invoked, bullied and commanded *ogede* but the matter seemed to have no solution.

Much later, however, I began to understand where I had erred. I realised that I indulged in magical arts but had failed to reckon with God. I forgot that He created the leaf and created the bark of the tree. Before daylight broke on my third day I cried to God and prayed:

'Ruler of skies, Owner of this day, this matter is much beyond me. Help me now, help me for I cannot do it by myself alone. O God, do assist me in this. Forbid it that I become meat for this creature; forbid it that he use my skull for a bugle. Let me not perish in this forest; forbid it that from this spot I become a voyager to heaven: let me not die the death of a fowl; forbid it that this man devour me as a cat devours mice. Let the masquerader worship the mask for as long as he pleases, he must return to render account to you; let the follower of Sango serve and serve Sango, he must render account to you; let the devotee of Oya bow

to Oya, he must return in the end to you and render accounts. The Moslems worship you as Anabi, the Christians offer you every minute of their existence. I implore you rescue me, I cannot alone save myself, God Almighty, save me from my plight!'

Even so did I pray that night and I rested my hopes in God. The following morning when the man emerged as usual and offered me the usual raw yams, I was inspired by God to ask him a small question.

'Pardon me, Master, I beg of you, do not fail to tell me why it is that you do not cook your yam before you eat it.'

He looked at me with wide-mouthed astonishment and confessed that he was not aware that there was such a thing as went by the name of cooked yam. So I elaborated further on it, saying that when yam is cooked it is far more delicious than when it is eaten raw. So he asked me if perchance I could cook this yam for him and, when I answered yes, he unchained me. I made a fire and cooked the yam, and when it was done I peeled and offered it to him. When he tasted this yam it tickled his palate no end and he began to talk to me with interest.

As we were speaking thus we touched on the subject of the gun and he demanded to know what was the use of it. I replied at once that it was a gadget for enjoyment, and that if I thrust the muzzle of this gun in the mouth of anyone and gently caressed its stock at the base, water would flow from the gun of such a quality that the man would experience no thirst for seven clear days. When he heard this he hurried into the cave and brought out my weapon, eagerly he thrust the muzzle in his mouth and bade me caress it at the base. The bird is already eager to fly and idle hands pelt it with stones — this was exactly how the matter

was. I took the gun in my hand, blazed away and heard it roar. Down fell the man, dead.

Even so did I bring about the end of this man, but I must rejoice no further, for I had not the least idea where I was. But first, after I had despatched him, I entered the cave, and when I was deep inside I discovered all manner of precious things —*segi*, coral beads, waist beads and expensive cloths such as velvet, *san-yan*, red northern, dyed cloth and exquisitely seasoned *kijipa* which had been smoothly beaten. And I discovered various kinds of headgear, *okiribi*, dog-ears and plain hats. I found also three crowns which were made of beads; if a king put these on, his face would be invisible, for these beads hung down right round the crown; they were beautiful beyond words. I found a stack of yams also, and took some which I cooked. After this I selected the most valuable of these treasures, packed them properly, took my gun and my hunting-bag and began to feel my way around until I could arrive at a familiar spot and head for home. But rather than soften, the fronds of the coconut palm merely stood stiffer. The more I sought a way out, the deeper I was lost.

After some time I began to hear the sound of drumming from the spiked grassland and I turned in the direction of the drums. Before long I came upon a settlement; it was a city of ghommids. These were different from the usual run of ghommids; they were just like human beings and both male and female were attractively attired; they were like birds of elegant plumage. On the day of my arrival the crown prince of the town was holding a celebration and the entire populace were gathered in the market square; their king was seated on his throne watching his son dance on horseback. When I first came there they were all engaged in dancing round the prince; they were so

immersed in their dance that they did not observe me, but their *king* had seen me from the first and had instructed someone who stood close to him to summon me to him. I went, and when I was close to him and saw that he was a king, I prostrated myself full-length on the ground, poured earth on my head, and saluted him 'Kabiyesi!'

He thereupon told me to rise, turned to me and spoke thus: 'There are many ghommids upon this earth who hate the sons of men. They frighten them by day and chase them about at night, they indulge in the habit of taunting them and they talk of them with contempt; but I disapprove of such ghommids and love to make friends with human beings, for there is wisdom in them. Therefore I want you to put down your load, sit at my feet and enjoy the festival.'

I was truly happy to hear this from the king and as I sat down I observed that the drummers were not really performing too well, so I sought permission from the king to take over from them and he granted my wish. He called the lead drummer and told him to give me a drum and bid the others keep silent a while; I was then handed a *gangan*.

A long time before while still a child I had learnt how to drum; whenever I did not accompany my father on his hunting trips, I would follow round after a certain relation of mine whose profession was drumming. This gave me greater honour among these ghommids; I took the drum and set to work and all of them began to dance. My good friends, these ghommids most assuredly could dance; they danced better than grubs. When I had truly excelled myself, the king himself rose from the throne and plunged into the dance. I was now thoroughly aroused and I dug the crook into the drum skin, darted into the fray and crowded the king with music.

It was a long while before the dancing stopped, and the king took me to his palace and placed delicious dishes before me. When I had dined he made me a gift of a house, boy servants and maidservants to live with me and insisted that I make their city my home; but should I wish to return to my home to look up my own people, he would provide those who would accompany me so that it would be as if I merely visited there as a stranger and would return immediately. His words sounded good to my ears and I accepted.

I stayed very long in this town and I enjoyed myself beyond measure. The king loved me more than life; everyday he sought new ways of diverting me, he indulged me and contented me and treated me truly as a son. Even so did many of the townspeople extend favours to me, they also loved me like a paramour. As for me, I had resolved within myself to render satisfaction to them all even in so far as it lay within my power. There was nothing which any one of them would request of me which met with a denial; there was nowhere the king would send me that I would not go: it was much as if we were all children of the same mother.

But no matter how numerous are a man's wives, he will not fail to have a favourite among them. I had a friend in this town who grew closer to me than the rest of them; he was a man of great fame and possessed a great deal of influence in that town. And it so happened one day that my friend came to me and said, 'Akara-ogun, would you ever guess that the people of this town plan to kill the king? It is painful to have to tell you that they have plotted this thing, that they have even conspired with a favourite wife of the king how they will achieve their aim. This woman has been given a kolanut which she is to offer to the king, and it

is most certain that if the king eats the kolanut, he will die an instant death. These citizens have been at the matter a long time and it was only last night that they took a decision on it; I had to come at once and tell you about it.'

I was greatly frightened to hear this and I went to the king and told him everything. He very nearly refused outright to believe me for he had placed absolute trust in this woman. But in the end, he agreed that when the woman offered him the kolanut, he would not eat it but hide it carefully.

The following morning after the king and his wives had eaten, his woman hailed the king and said, 'Kabiyesi, there is a little matter I forgot to mention yesterday. I visited with another of your wives a friend of yours and he made us a present of four kolanuts. We shared them between us, and my portion came to two. As you know very well I cannot eat anything and ignore you, so I kept yours wrapped in a leaf when I ate mine. I even meant to give it to you yesterday but it escaped my mind. But that is just as well, for this kolanut is especially good for a snack after the kind of meal you have just eaten — here it is now my lord and husband, kindly accept it for what it is worth.' When she had finished she placed the kolanut in the king's hand, but instead of eating it he hid it carefully and pretended that he had eaten it.

The day passed but the king did not suffer stomach ache nor did any harm befall him. A new day dawned, yet he woke in good health, and moment by moment a week passed and the king remained fit as solid rock. So after a while the conspirators met again and sent for the wife; they asked her how it was that matters stood thus and when she had recounted how she performed her part towards the king, she said:

'You must not imagine that I deceived you at all, I want you to know most assuredly that there is no way in which I have benefited from this man from the day that he claimed to be courting me. Is it not true that anyone who sees me in the streets will imagine that it is he who takes such care of me? A lie! rich as he is he cannot spend a halfpenny for the good of another being. Let us thank the shoulder but for whose aid the garment would fall off the body; it is thanks to my mother that hunger has not plucked out my eyes. But for my mother I would be walking through the town centre and flies would swarm on me and dogs bark at me. He is meaner than the dog who vomits his food and returns to eat it. Observe him carefully enough and you will discover that the man is exceedingly vain; when he has finally persuaded himself to visit some other kingdom and observes how the king's wives bear themselves in other parts he returns home and begins to make his pathetic efforts, persuading himself that he actually wants to make a new outfit for this wife. Abominated head, pachydermous neck, there is no remedy but that you must kill him. And here is the way to be rid of him. It is only a small matter—late tonight when everyone is asleep I will go and open up the palace gates; appoint four muscular thugs and let them enter sword in hand; whatever room you notice with open windows, enter, for there the king will be. Whoever you find within it, give him his death.'

So counselled this woman in conspiracy with the townspeople; she denied her husband because of money. May God in his Mercy not leave you men to encounter such a woman.

The house where I lived was within the palace and it took some time before news of this new intrigue of the townspeople came to my ears, but the moment

I heard I rose and went to the king's quarters. When I arrived at the backyard directly opposite the room where the king and this evil woman normally slept, I sat on the ground and watched to see if before long a window would open. Sure enough before I had sat for a while I saw the woman open a window, in fact it missed my head by very little. After this she opened the door leading to this room and proceeded to open several doors along the route to the gates. As she acted thus, I watched her, and when I knew that she must have passed through all the doors to the gates of the palace enclosure I quickly went into the king's bedroom, woke him up and took him by the hand. As soon as he looked at me and recognised me he wanted to say something, but I waved him into silence and led him out, took him to my bedroom and told him to sleep there. Then I returned to his room and shut the window.

Not long afterwards the woman returned and went to another room to sleep. I waited some time until she began to snore, then opened her window and went my way. But not yet to my house; I went and sat in a certain alcove which opened out from one of the palace buildings, from where I could see clearly into the compound. Hardly had I sat when I observed the four appointed men enter sword in hand; they followed their course towards the house of the king and I rose softly and sneaked after them. As soon as they saw the open window they leapt into the room and — before a bird's touch-down — they had slain this woman and cut her up in small pieces in the belief that this was the end of the king. They lied in their teeth: to him who casts ashes, the ashes must return; whoever invites trouble, trouble seeks him out; whoever calls on contention, contention will answer to his call; evil cannot fail but end a heart of evil. Thus did this woman die the death

of a dog and rot like bananas: even thus did the King of Heaven raise this righteous king in triumph above their schemes.

The king was thoroughly mystified by my actions and it was not until the following morning that I explained it all to him. When he heard it he was greatly frightened, he rendered praises to God and he thanked me most fervently. After this incident I asked him to go and inspect the kolanut wherever it was, which the woman had given him that other time. He found it, it had turned to a foul egg, blotchily bloated. Had the king eaten that kolanut, even so would he have swollen round his stomach like a yam tuber.

So did God rescue the king from the second danger, but his enemies had prepared yet another for him.

There was a most vicious beast in this kingdom; it was a one-eyed leopard. He menaced the townspeople at will and preyed on them as he pleased and, no matter how hard they tried to kill him, the effort proved futile. Eventually the entire town met in assembly and summoned the priests of Ifa with whom they conspired that the entire priesthood of the Oracle should go to the king and bid him send a crier to summon the population to the market square. The crier would announce that the priests had a message to deliver which had come directly from the lips of the clan-spirits, so that when the king had obeyed and the entire people were assembled, the Head Priest would address them all in the following words:

'Rest well you people of our town; it is upon this matter of the one-eyed leopard that we have summoned you here to speak and deliberate with you. The guardian spirits advised us recently that the only way to stop the menace of this beast is to call you all together and let us voluntarily select one man among

you as an offering to this beast — the significance being that this individual takes away from us the sins of the entire city — also that the person so selected must volunteer himself for we must not enforce this on anyone. The spirits said further that if we cannot find anyone among you to sacrifice himself for others in this manner, whether we like it or not we must make a gift of our king to the beast. Should we fail to do this, instead of the one beast we shall be plagued with seven such creatures, each one surmounted by a hundred horns. This is the problem which we would like you all to consider carefully.'

It is true that these people planned a great treachery and embarked on a great conspiracy; but they forgot that he whom God himself does not apprehend, no man can harm him. Do you not see the nature of the words which these men had placed on the tongue of the Head Priest? They knew very well that there was no way in which the king could escape; for clear it was that none of them had set eyes on any guardian spirit, and there would be none who would rise and walk into a pointless death. And the entire city was present when this plot was hatched, so it left only me, and the king, only a wife of the king, two children of the king and a servant.

So the priesthood came to the king and addressed him as planned, and the king obeyed them without any suspicion; he summoned a town assembly.

When they were all seated the Head Priest rose and spoke as the people had schooled him. As he ended his set piece he enquired if anyone there was prepared to make himself a gift to death but no one rose; they stared blankly at one another. In the end the king rose and said that since there was no one present who would respond with a proud breast to the matter in

hand, he was quite ready to go and provide the beast's next dinner. With great rejoicing the people gave a shout of approval, they began to offer their thanks of hypocrisy to the king.

I waited patiently for the king to have his say, and as he sat down I rose and addressed them thus:

'Kabiyesi, you will die no such death. I here will take your place, and I am all ready to go.'

Upon this the king looked at me and burst into tears. He begged me not to go but my mind was made up. He pleaded a long time but I said, 'Come rain come thunder I shall go.' My will was fully aroused and all his words simply by-passed my ears. I rose from the ground like air and told the ghommids to lead me to the dwelling of the beast where I would meet my death. Thus did they all follow me with great anger, there was no sympathy for me because, they claimed, I had brought it all on myself. Before we left, I sent home for my matchet and my thin, double-edged dagger. These were brought to me, and so, accompanied by dagger and matchet, I set off. But these ghommids only laughed and scoffed at me because even more valiant efforts than mine had failed to kill this manner of beast, according to their thinking.

Soon we arrived at the cave; it was a big cave and lay within an enormous rock. As I got there, I drew my matchet, gripped my dagger, tautened my trouser band, and uttered a spell that the tiger's claws be sheathed. I then entered the cave and began to seek him everywhere; sure enough my spell had worked, the creature's claws were drawn in even before I encountered him. As soon as he spied me he homed on me without deviation, and pounded towards me. And even though it was true that I felt terror at the sight of him, yet was I determined to show him a thing or two

before he eventually killed and devoured me; in my hand my knife was tightly held. When he was only a short distance away he leapt upon me as a hawk might dive on a chicken but I stood firm, because even before he leapt I had resolved to blind him and I had set the dagger at the target of his eye—this very leap took his eye smack on the point of the knife which was driven in to the hilt. After this I retreated a little but he was surely blinded and, as the venom of the knife seeped further into his body, he rampaged around desperate to find me, and if he had encountered me in that state it would have been a sorry tale indeed. When I saw that he had begun to tire a little, I drew near to him and seized him by the neck in an attempt to twist his neck backwards, force his back to the ground and stab him in the soft of his belly with my dagger, but he easily tossed me off and I hit a rock on my back. At once he dashed forward hoping to catch me where I had fallen, but I was in a different spot. I did not stay down too long because I saw that he had tired even more, so I made the effort to rise, seized my matchet and tip-toed towards him; when I had moved within reach I gathered all my strength and struck him on the neck. The blade penetrated him a little and, before he could turn round, I seized hold of him and we began wrestling in earnest. We wrestled for a long time and threw each other many times, but in the end he fled, so I hung on to him, tucking my matchet in my trousers while the beast dragged me along with him. He pulled me about for some five minutes before he tired completely and stood still, panting heavily. When I observed this I seized him about the wound on his neck and pulled him back with all my strength; he fell on his neck and before he could crawl back to his feet I struck him a death blow and his intestines

splashed out of his stomach. Even so did I overcome this evil beast.

Now it was one thing to kill him, it was another to carry him out of there; and yet it was clear that if I did not bring him from the cave my glory would not be apparent to the world. When I seized him by the legs and applied all my strength to drag him out, he merely settled back in position, he was much too enormous. At first I was afraid and began to doubt whether I would fail in this task, but the more I thought about it, the more I was convinced that I must make every effort before I gave it up. So I sat gently down and rested a while. When I had rested, I took both my matchet and my knife and tucked them out of the way in my trouser band; I seized the beast by the legs and began to drag it out. My friends, it did not seem possible, but I dragged that monster out. As I re-emerged into sunlight I set on the road to the town and dragged it along, by six o'clock in the evening I appeared in the town and shouts of wonder re-echoed among the people. They stared at me with open-mouthed amazement.

Since my departure the king had not stopped weeping for he thought I must surely be dead. Those who had accompanied me to the cave were also convinced that I was dead, for when I entered the cave and they had waited a little without my returning, they went back home and announced to the people that I had met my due.

You can, my friends, yourselves imagine the overflow of joy in the king when he set eyes on me. His happiness was indescribable, and from then on I became a dearer friend and became so great a confidant of the king that he would embark on nothing without letting me know. My word in that kingdom was law. But when the stunted palm begins to grow the forest

giant bursts with resentment—this was my fortune; my relationship with the king did not please the majority of them and they sought ways of setting us at loggerheads. They began to vilify me before the king, they lied and lied, they plotted and plotted but he paid no heed to them.

It so happened that the king owned a dog, a unique dog it was, with teeth of pure gold and fur of bronze. It was a gift from Sokoti the Smith of Heaven to the king on his coronation. The king was deeply attached to this dog and often swore that if anyone harmed the dog and he found him out, he would hand the culprit to the youths of the town to devise for him the worst punishment they could think of.

From the moment that I began to live in the town I had looked after this dog and protected him from possible maltreatment; he grew to know my face very well. But one day I missed the dog. I went to the king and asked him if he had seen it, he said no. Both the king and I searched for a long time but to no avail. In the end the king sent out a crier for the people to assemble; soon they were all gathered in the market place, the king among them, seated on his throne, and I on the right side of him relishing my closeness to him. He began to speak and told them how it was a great sorrow to him that the dog which was a present from Sokoti the Smith of Heaven to mark his coronation, should be lost, and that both he and I had searched everywhere but without success. And he begged the townspeople for their help in tracing the dog.

He had hardly finished when a man rose and said: 'Kabiyesi, noble king, may God grant you a long life, may the King of Heaven forbid that you die an unexpected death, may your Creator never let sickness pin you to the ground, may the King whose Word is

Law protect you from the enemy within and the enemy without. The watercress floats above water, the water lettuce surmounts the pool, you will always triumph over your enemy; the prop of the rodent snare always falls forward, your hand will always move forward; no one sees the end of the ocean, no one can see the end of the seas, no one will witness the end of the skies; those who will surely be destroyed by their own envy cannot see the end of you—never! I thank you greatly for bringing this matter before the people. Surely there is no one who knows what that dog meant to you who would not grieve for you, and there is one thing which I want the entire people to know—this dog was stolen, and the thief is one who is quite close to the king. It is my opinion that, if the matter is to be properly pursued, we must investigate the man who first informed the king about the missing dog. It is this man we must insist should find the dog because he was the first to know it was missing, and he alone can tell in which place it lost itself. Live long, live honoured.'

As soon as he ceased another rose and gave support and encouragement to the opinion of the first man, saying that the man who first informed the king would need close questioning—this man being me.

The third man who rose to speak was my bosom friend, he who in former times would reveal their secrets to me; he began to speak, and his words went thus:

'I greet you all, people of this town. I greet you in your deliberations, may God grant that this manner of thing does not bring us together too often. *Howu!* The witch howled last night, the child died today, who then does not know that the witch it was who ate up the child! Who here does not know that Akara-ogun stole this very dog! Well, look at me, am I not his bosom

friend? He has planned this thing for a long time and he finally fulfilled his aim two nights ago. I warned him but to no avail—he is a truly hardened thief. And my own counsel in this matter is that this town must deal with him as he deserves, for he is a most evil-headed man: as for me, it is clear that I must break off our friendship from here on, lest he bring his own ill consequences onto me.' When he had spoken thus he turned to face me saying, 'Ah, so this is the face of a thief! When I warned you to desist from stealing did you listen? When I told you to quit loose talk did you leave gossip alone? When I counselled you to desist from acts of envy, did you desist? You who arrived here like a slave, the moment you felt secure you began to play nobility, toadying up to a king not your own. Do you not know that disgrace must be the end of the excessive and that every day might seem to belong to the robber but one single day is the day of the owner? You who enter a strange town without first observing its custom; daylight has caught you unawares, the king must fulfil his promise and hand you over to the youths for punishment.'

My friends, I trembled to hear the words of this man, and when I opened my lips to reply it was only tears that fell, for populous as this town was it was only this man whom I loved before all else. We came home together and our outings were together and whatever he spoke about me deserved to be believed, yet, every word he had just uttered was nothing but calumny against me.

Eventually, I did find my tongue and began to speak. 'Indeed, the truthful are no more and there is none of them to be found; there are few men left under the heavens in whom another may trust. To ward off contempt I had eight hundred friends so that if

four hundred decried me, four hundred would praise me. Ah, you who are my companion at drink and companion at table, do you join with others in plotting this treachery against me? Indeed, I can hardly blame you. It was I who summoned war and found war, it was I who summoned treachery and found treachery, it was I who with my own hands pulled stinging nettles close to me, it was I who took a perfidious man for friend, who invited a robber to rob me, who placed shoes on the feet of a country bumpkin. But, the butterfly which rams a thornbush soon finds that its own clothes have met disaster, whoever acts evil will certainly fall by evil—before I die this day, I will first grant you your own deserving.'

Even as I spoke, my thin pointed dagger was in my waistband; as I stopped speaking, I drew it out and stabbed him to death. And when I observed that the elders of this town began to rage at my action, I went in their midst and stabbed them also and killed them, sparing only the king.

After this I ordered the youths to bury them, but the earth turned to stone and refused to take their corpses, for theirs was a death in sin. So I again ordered that their bodies be cast into the sea but the sea refused them and threw them back on land. And I told them next to place these bodies on trees but the trees dodged them. Even as they fell back towards earth, a chain descended from heaven and tied them up, leaving them high up in the air. And there they stayed until they began to rot, the birds of the air flew down on them, excreted on their heads and pecked at them.

All these acts, however, only incensed the youths further but, because of the approach of night, they did nothing to me but returned to their homes and I to mine.

I woke very late the following day, the sun was already up. As I rose from my mat and made to saunter out, I saw a numerous crowd of people armed with cudgels and cutlasses, coming in my direction. It did not even occur to me that it was I whom they were seeking, I had no suspicion at all until they were actually upon me. I had only a coverlet around me, and before I could enter the house to put on some clothes they had seized me. In a second my arms were tightly bound behind my back; next they entered the house and brought out all my valuables, both those which I had acquired in this town and those which I owned before I came there; they tied them in bundles and placed them on the heads of children. I was taken through the market and whipped as we went; my body was raw and full of weals.

When we got to the market, they ordered me into a hole which had been dug in expectation of me. I obeyed and found that it came up to my neck; only my head appeared above ground. They made me stand straight and then began to fill up the hole, pounding the earth hard against my body. Next they took up a matchet and began to shave off my hair. When it looked clean enough they poured honey over my head so that flies of all kinds buzzed round it in swarms. They proceeded to spread my goods all around me, placed all kinds of food before me and an inscription on a signpost which read—'With your eyes behold this, but your lips will not touch.' They tormented me in every conceivable manner; I wept until tears were exhausted in the home of tears, I pleaded until pleas were finished in the home of pleas, but the seasoned witch, sooner than experience a change of fortune, simply gives birth to daughter after daughter, so witchbird swarms over witchbird: instead of taking pity on me they redoubled

their jeers. In the end they all left me to my fate and went their ways.

At this stage I had resigned myself to death; certainly I had no hope that I would ever escape from my present plight. But God had seen their act of wickedness and resolved in his mind to rescue me. They buried me about half past eleven in the morning; about two o'clock the clouds began to gather and before long it began to rain. The rain was truly heavy and did not cease until about eight o'clock at night. As you will realize, it was upon my head the rain began and on my head also did it stop, but even though this heavy storm punished me it had also been helpful to me in one respect. For I realised after it was over that the soil had softened a great deal, and I moved myself about to see if I might extract myself. I saw indeed that if I applied some effort I could climb out, and after some struggle and some time, I did. Quickly I took a few of the more valuable among my possessions; I ate a little of the food, picked up my things and fled into the night.

My condition, which was a tired one, made my feet rather infirm on the ground, so after I had walked sometime and arrived at a certain pit, I went down into it. This turned out to be the pit which was used by the townspeople for disposing of their dead livestock, for they would never eat an animal which had died on its own. This gave the pit an unholy stench and I was no sooner down it than I stepped on the festering head of some such animal. Backwards or forwards I could not find a patch of common earth, the place was filled with the carcasses of animals. So I reached down on a goat that appeared freshly deposited and attempted to sit on it, little dreaming that it was at least four days dead and its seeming firmness. simply bloatedness. The moment my buttocks hit the carcass, it burst, and the gall

bladder and intestines flushed my buttocks with their fetid fluids.

When I thought upon these new tribulations, helpless tears flooded me. At that moment even death seemed preferable to life. But my Creator again took pity on me and sent a messenger to me; it was a most beautiful woman, and when she came to me she took me by the hand and bade me follow her. Still weeping I followed, and after we had walked some distance in this pit we came to a certain well-appointed house. Several boys and maidservants were in this house, and each of them more beautiful than the antelope. It turned out that this woman was the head of the household. As we stepped in she ordered the servants to bathe me in warm water and rub me in sweet-smelling unguents. After this she gave me a velvet coverlet and placed the most delicious food before me. When I had eaten I rose and would have prostrated myself to her because of excessive joy at my situation, but she forbade it. Next she showed me to a room and pointed to a bed where she told me I should sleep. My head was no sooner down than I slept off, and it was not until the afternoon of the following day that I awoke. She woke me up, inviting me to eat.

This woman again took such care of me the following day that I nearly resolved that there was nowhere better to hunt than the Forest of a Thousand Daemons. The drunkard had forgotten toil, I forgot all the suffering I had undergone. And her hospitality on the third day was simply indescribable.

On the evening of the third day the woman complained of a headache, so I sat beside her, took her head in my hands and began some incantations for its cure. My good companions, it was even as I uttered these healing words that the woman died in my hands,

and, as she died, a bell rang and all the members of her household came towards me and died there about us. I thereupon endeavoured to die also but this proved impossible and I said to myself, what new visitation is this? I could not sleep all night, I alone living among all the dead — I was terrified of them. Early the following morning I cried up to my mother and bade her come out of heaven and attend me where I stood. I called her the first time but there was no response, I called her a second time and still I heard nothing, the third time I bellowed out in anguish saying:

'Ah Mother! Mother! Mother! Why do you fail to answer me at this hour? Why do I detect no sound of your presence? Is death not preferable to scorn for me? Had I but died at home, that would have been much better than this present plight. Is it fitting that I should perish in this wilderness? Is it proper that no one should know what earth covers me? This world favours me ill; I emerge from the home of death to the home of illness, I go from torment to contempt, my life proceeds lacking head or tail. Mother, dear mother, true mother, most complete mother, mother who turned out well in life, sharper than sharp mother, mother to be reckoned with, larger-than-life mother, far from wicked mother, an elite-on-earth mother, a famous-in-heaven mother, mother who dined well on earth, mother who wines well in heaven. Ah, you invaluable mother, wherever you are this day, do not fail to let my eyes behold you.'

When I had cried out thus, the earth was rent suddenly open and my mother appeared, and seeing me with tears in my eyes she also began to cry. She embraced me, caressed me on the head, saying, 'Why do you summon me thus, my child? Tell me, do tell me, I want you to tell me, my son. I know that in this

world your portion is hardship for you are a valiant man among men and a famous figure in the world. God will not deny you a long life, your Creator will not hide riches from your reach; but try, try to benefit this world before you die and leave it better than you entered it. As for returning home, that you surely will, nor will you die in the prime of youth. And also, when you have become aged, life will hold you esteemed, for there is nothing more harrowing under the heavens than the sight of an elder who is not yet free from toil. Therefore tell me if it is on an important matter that you have thus summoned me so that I may exert myself for you and make you happy.'

When my mother stopped, I wiped off my tears and told her that it was the fear that I could not escape from where I was which made me cry to her, and I told her also of the number of cruel experiences I had undergone. After this she brought out a tasty cake which she offered me and I ate it. Then she bade me follow her and I followed her. We did not walk too far before we came to a tunnel. There she dug her hand in her pocket and brought out a stone; this stone was very smooth and was white as cotton fluff. She instructed me to throw this stone into the tunnel and follow it wherever it rolled. And she assured me that if I did so I would emerge before long in a different section of the forest where I would meet another hunter who had been lost for a very long time. And she promised further that I would not encounter too many hardships from that moment until my return home. When she had said this, the earth yawned again and swallowed her, and I did as she had instructed me.

※ ※ ※

AKARA-OGUN AND LAMORIN

I walked through this tunnel for about an hour before
I emerged into the light, and I picked up the stone and
kept it in my hunting-bag—since the beginning of my
recent hardships I had stuck close to my gun and my
hunting-bag. No sooner was I out than I encountered a
man whose name was Lamorin; this man had been lost
in the deep jungle for the past three years.

When he set eyes on me he rejoiced right down
to his deepest marrow for we were neighbours in my
hometown. We exchanged affectionate greetings and
we exchanged tales of our adventures—my own expe-
riences were nothing compared to those of Lamorin,
for it was a long time indeed since he had been lost, or
last set his eyes on his home.

We journeyed together and arrived at a certain
river. As we went along the bank of the river we saw
a giant of a man before us; he carried a huge bag over
his arm and was stark naked. In his hand he held the
head of a lion which he chewed as he walked and, as
he caught sight of us, he dropped the head and made
directly for us. Instantly I heard Lamorin cry out loud
and warn me to take to my heels; when I asked him
why he told me that this very man was called Ijamba,
or Peril, and that it was he who had fathered Loss who
lived in the household of Starvation. So we held rap-
id dialogue with our heels and he sped after us. Soon
I could not see Lamorin nor did I hear any signs of
Ijamba, so I rapidly climbed up a tree with bag and
gun, waiting until I could hear or see signs of either.

Shortly afterwards, I saw Ijamba coming in my
direction looking here and there in his search for us.
When he got quite near me I heard him moaning, 'E-eh,
my unlucky head, my unlucky head! These succulent

grubs have truly escaped, what will be my supper to-night?' As he wailed thus he raised his head and espied me. Ah, but his joy was great! He reached out a long arm and seized me, threw me into his bag and went on his way. I kept calm, but then my gun was in my hands. I loaded it with large shot, primed it soundly and rested a little. When I had rested I slammed the shot into his skull and he fell down and died. Thus did I put an end to the life of this man whose name was Peril, and I raised my voice to summon Lamorin. He was most happy to see Peril flattened on the ground like a log of timber.

We went to a lodge which Lamorin had built nearby and there it was we spent the night.

We had no sooner finished preparing our supper that night, and had sat down to eat than a tall figure arrived, greeted us, and sat down to join us at table. I recognised at once that he was a ghommid, and when he had taken two morsels from the food, the meal was over. This was the breaking point, and I quietly took a large broken pot which we had used to build a hearth and slammed it into his neck. He leapt up and went off wailing. The following morning we found the potsherd around the top of an iroko tree, but how the sherd on this ghommid's neck had transferred to the neck of the iroko tree was all a source of wonder to me.

We slept that night, and the following morning Lamorin and I exchanged the day's greetings, ate, seized our guns and went our different ways in search of game.

I had walked only a small distance before I saw a one-legged creature lying asleep in the crevice of a tree, his crutch leaning beside him. I went forward to where the crutch was and took hold of it, my intention being to sneak it away from him and then watch

how he would move upon waking: but the moment I touched it, something within the crutch cried out a warning. The man was instantly awake but before he could react I had snatched the crutch and, escaping with it, stood some distance away and laughed at his discomfiture. He pleaded with me for a long time but I refused to release it until he promised to give me some spells for hunting. He then said to me:

'I am Aroni, the one-legged ghommid. Evil in my home is inexhaustible but so also is good within my home. I was a most wicked ghommid who rebelled against God; the good king Solomon admonished me but I paid him no heed. Such was my arrogance before God that he punished me and turned me into this one-legged creature. I have lived eight hundred years in the world and still does my nature go with me, so God in his anger decided thus, I will leave you to your ways until you have suffered much at the hands of Death whose home is in the dome of the heavens. And it is Death whom I now await, so return my crutch to me, and I will make you a gift.'

Hearing these words, 1 took pity on him and returned his crutch, and he gave me a magic powder. All I had to do was sprinkle it on the spoor of game, and whatever animal on earth left the spoor would surely return at once to die on that very spot. I tried this powder and it proved fire lethal. But I did not use it too often lest I quickly exhaust it.

I had not long left this ghommid or progressed any great distance when I met a remarkable creature who was no taller than two feet. He had two heads and two horns—one horn to each head. He was possessed of only one eye and this was placed squarely on his chest. On meeting I greeted him and he greeted me courteously, but his voice was rather out of joint because he

employed both mouths in speaking at once. I asked him, 'Where do you come from and where are you going?' and he replied, 'Why are you curious about me?'

Whereupon I said to him, 'I notice how short you are and observe that you bear two heads about with you.' He replied, saying 'Indeed I have two heads and I am remarkably short; my name is Kurumbete, he whose home will be found on the other side of heaven. I was one of the original angels who were much beloved of God, but I rejected the laws of God and His ways and engineered chaos in heaven. God saw that I was intractable, and that my genius was an evil one. He handed me to Satan to inflict agonies on me for seven years, and even so did it come about that I lived in Hell for seven clear years. I returned to God after the seventh year but He perceived that there was no repentance in me, and He said in His great anger, "You pester me, you ant; you kick at me, you less than the little sand-fly. This day will I split your head in two and prevent unity of thought in you. I will sow confusion on your tongue as I did among the dwellers of the Tower of Babel when they grew overbearing in their ways. I shall cast you into the wilderness and there you shall be a wanderer until a son of earth throws earth upon you."

'And so has it been since that day, you good hunter. Therefore I implore you to cast a little earth on me for I am truly weary of this wandering.' I was full of pity for him and threw earth upon him, and instantly he turned into a large boulder rooted in one spot until the end of the world.

As a result of these encounters, the ghommids were much reduced in my estimation; I had no further fear of them and I continued normally about my business. As I wandered about I met a remarkably

beautiful woman and was greatly drawn to her. I greeted her and she returned my greeting, but when I asked her how she came to be wandering in this wilderness she made no reply. After this I begged her to be my wife but she refused. I pleaded and pleaded but she would have none of me. Thereupon I tried to frighten her, threatened that if she did not consent to wed me I would shoot her, but she retorted that my gun could not affect her in the slightest. In my mad anger I turned the gun on her and fired, but the gun resounded merely, no shot emerged from it. Then she turned and looked at me for a long time and said, 'If I did not take pity on you I would kill you this very instant.' But I told her straight that she could do nothing that would in any way harm me; she turned on her heel and continued on her way.

But her beauty drew me to pursue her and I followed and held her by the wrist. She stared me full in the eye, fell down and turned into a huge tree; but I hung on to the tree because this woman attracted me wondrously. Then I saw this tree transform itself into an antelope with flaring antlers but I held on just the same. She struggled for a long time but my hold on her remained unbreakable. Later she turned into a roaring fire but I did not release her, neither was I harmed by the flames. She underwent many transformations: she became an enormous bird, she turned to a stretch of water and then turned to a serpent, but I held on to her and there was no breaking my hold. At last she returned to her form as at the beginning; she looked at me and smiled, saying 'I will wed you, you fearless hunter.'

And she was married to me and we became man and wife, Lamorin officiating as priest. I threw a large feast and the affair was truly grand: when man takes

ghommid to wife, the natives of earth and heaven banquet fit to burst.

Lamorin and I were friends, we were very fond of each other and did not like to be parted. One day we went hunting, and before we could return, night had already fallen; the oil was used up in our lamps but the moon was bright as daylight. When we had been roaming around for some time we reached a huge rock, truly immense. Its mass was pockmarked with deep holes and all the approaches to these holes were worn dazzling smooth. Lamorin said that he wanted to pass the night in one of them; I warned him not to but he stubbornly insisted. When he had gone I climbed a large tree to its top and stayed there watching the visage of earth. Not long after there appeared an outsize creature; he had four eyes and six arms, he had two bristling horns, and he had come out of one of these holes with a broken calabash full of blood. He took it to the base of a tree which stood in front of the rock, and I heard him say, 'I give thanks to you O lord of mine, for I know that it was by your powers alone that this venison came in of itself to meet me in my den. Grant that such blessing be mine all the time, and thank you once again.'

This was all to which I was witness. I waited till daybreak but Lamorin did not emerge. At break of the following day I shouted his name, but received no response; in a panic I came down from the tree and rushed home to tell my wife. And of course my wife, since she was no ordinary human, knew already what was the fate of Lamorin. She said, 'Alas, that man you saw is known as Tembelekun, his elder brother is known as Bilisi, and his home is in the Bottomless Bog where my own mother was born. Tembelekun married my junior sister, and they had a son whose name

is Chaos. That child grew up and sought employment under Satan who is king of hell. I learnt later that Chaos was a most conscientious worker and earned rapid promotion at his job, and it pleases me greatly to learn that he is at this moment foreman of those who feed the fires of hell with oil. The only thing that I detest about these employees of hell is that their bodies are sootier than the hearth, and their cruelty is worse than that of monkeys. Therefore, my husband, I greatly fear that Lamorin has fallen into the hands of Tembelekun, for Tembelekun eats neither yam nor maize, the human head alone is his meat—ah, what a pity!' Tears fell from my eyes when I heard these words, I cried until my anguish filled the forests, I moaned like a lion in pain, but not all my grieving would bring back my friend.

Since my mother had rescued me from my confinement and I had met Lamorin, my mind had shifted from thoughts of home; I had come to love the Forest of Irunmale. But with Lamorin dead I was again tired of the place and I began to consider ways of returning home.

One day when I went to the bush to hunt, I happened on a little trail and followed it, determined to go with it until it petered out. About noon I arrived at a little hut which was familiar, and met a little child in it, and when I inspected him closely it turned out to be my cousin, the child of my uncle who was born after my mother. I was exceedingly happy and I shouted to my uncle who was on his farm; he came, embraced me and was full of joy. He asked me where I had been and why I had stayed away for so long, but before I replied I asked him to wait while I fetched and brought home my wife, and he agreed. So I returned to my lodge to bring my wife with me.

I had not walked for ten minutes when I met my wife. This was a great surprise for I had left her at home and I asked, 'My dear wife, I am astonished to see you here. I do hope that nothing is wrong?' She replied, 'My beloved, my beloved, my most dearly beloved one, I did not guess that parting would befall us thus. My eyes went with you when you reached that hut and met your own people. A spirit like the ghommid can not join with human beings to live together, for evil are their thoughts every day of their lives. Take this little cloth, it is a gift for you; whenever you are hungry ask anything of it and the cloth shall provide it. Ah me, because our love was great I did not think that such a final break would befall us at the height of noon. Ah, my dearest love, do not forget me until the day that the cock shall crow on your depleted flesh—the native returns to his homeland—fare you well!'

And with these words a man appeared suddenly, and he took hold of my wife and said, 'My sister, let us return to the Bottomless Bog where lies our home.' And straightaway I saw them no more, but there was the little cloth and I picked it up; whenever I grew hungry and demanded food of it, the house would be sumptuously filled with delicacies.

It grieved me that my wife had left me in this manner, so I went to my lodge and packed my possessions, which had accumulated since I was lost in the forest, and returned to my uncle's hut from where I eventually returned home. And thus ends the tale of my second adventure in this most terrible forest.

Since the day of my homecoming I put my gun aside and resolved never again to go hunting or embark on an arduous task. For one reason, because of the hardships I always encountered. For another, the things I brought back with me that second time were

so numerous that, when I had sold them, I was the wealthiest man up or down the entire kingdom—I was richer even than the king. And so this story ends as I said before, and since it is also approaching nightfall, I shall retire home and sleep. Tomorrow I will return and tell you all that is left to tell.

※ ※ ※

And so the man finished his tale and ate a light meal. After he was done, he shook hands with everyone who had come to listen to him, and afterwards I accompanied him some of the way and we shook hands a second time, saying to each other, 'Until tomorrow, may God grant that our reunion be with good.'

4

THE EXPEDITION TO MOUNT LANGBODO

News had gone round the city that a certain elderly man came daily to tell me tales of marvel, and before the early cock crowed the following day, the entire populace had arrived; they covered my home like a swarm of locusts. So when I saw the house would take no more, I began to spread mats outside the house. I unrolled mats until the mats were used up, then had to go round and beg for mats where I could. I borrowed a hundred and fifty before I could pause, and even these did not suffice; some climbed trees, many sat on the rooftop—they were as a flock of weaver-birds frolicking on the crown of the palm.

Not long afterwards the man arrived and, even as he appeared to us, he cried, 'I cast aside all that went before and bring you something new, so let you all retune your ears.' We all fell silent in anticipation and he continued to speak:

❊ ❊ ❊

'Ah, the sands on the sea shore cannot be counted, the works of God are truly innumerable. When I first set eyes upon you I was full of fear, but when I drew near my fear deserted me. For at first I could not help but think that when all of you will have died, all the iroko in the neighbouring bush will not yield enough planks to bury you; but in the end I took heart for I remembered that it is not everyone of you who will pass away in bed.'

These words angered his listeners who began to retort, 'I will surely die a peaceful death! I will surely die a peaceful death. . . .' While they were repeating this, he waved to them to be quiet and replied to them, thus, 'Words of truth are as thorns, the honest man is the foe of the world. I wish to ask you four questions; if you can answer them it means then that I am at fault in what I said, but if you cannot it means that you have not understood me at all. These are the questions: I would like one of you to rise and tell me precisely on what day he shall die; then I want him to tell me what manner of death he will die—by illness or from the crash of a tree, or will he be swept away by water? Thirdly, I would like to be told where this person will die—will it be at home or on the farm, will it be on the roadside or in his bedroom? In a strange land or in this very town? And lastly, this—let this man tell me step by step what things shall befall him from this moment until the day of his death. Let him not omit to tell me when he will stub his toe, when he shall fall ill, when he shall suffer bereavement, when a fight shall take place between him and any other, how many enemies he has already made and how many more he shall make in his lifetime. Let this man remember finally that the majority of lizards do indeed press their bellies to the ground, but we do not know which of them really suffers from stomach ache; we are sure only of those we love, not of those who love us.'

When he had spoken thus no one could reply to him, for no one can tell what day he shall die, nor does any man know what manner of death he shall die, neither can any man foretell in what spot he shall die or what events will happen to him until the day of death. So when he saw that our tongues appeared to be padlocked he said to us, 'Aha, I observe that you fall silent,

and the reason for your silence is this—the key to this world remains in the keeping of God. Were it in human possession there would be no illness, the poor would not exist, no one would ever know hardship, there would be no servants, everyone would be master in his own house—and the world would be much worse than it is today.' His words amazed us greatly; they were full of wisdom and we changed our tune and began to tell him, 'There is truth in this, old man; do carry on with your wise words.'

The old man thereupon began his tale and said:

My comrades all, I have beheld the ocean and have known the sea, water holds no further terror for me! My eyes have witnessed much in this world. Yesterday, I told you that scourges were my lot during my second sojourn in the Forest of a Thousand Daemons, and I told you how I resolved never again to hunt or set my hand on any arduous task. I must confess this to you, that promise I made, it was a futile thing. I performed yet another deed of an arduous nature.

It happened this way—it was in fact the season of harmattan and I rose late in the morning, for since I became wealthy I had taken to waking up late—too much thinking kept me awake most of the night. I had lately returned from my second hunting adventure and when the women of the town saw in me a new man of wealth, they began to beset my house in thousands, and I took them to wife with equal zeal. Many of them did I marry because they were not really interested in my character. They declared, 'It's your wealth we understand, we have no interest in your behaviour. Even if you wallop us with your gun and bash our heads with your hunting-bag, marry you we shall.'

But, before long, as they began to see my hunter's

ways and my riotous temperament which came from long dealings with beasts and ghommids of the forest, they began to sneak off one by one, until, on this morning of which I speak, only nine wives were left me. I was chatting with one of them when this hazardous business on which I was to embark reared its head. This is how it happened:

A king's messenger stepped through my doorway and informed me that the king desired my presence. This was cause enough for amazement and I rose, donned my *ɖanɖogo*, my dog-ears cap, my forty-four bottoms and, fully decked out, took myself to the king's palace.

I had no sooner come within sight of him than he called out, his cheeks bursting with pleasure, 'Akara-ogun', and I in turn replied, 'Kabiyesi, it is indeed I. May God give you a long life.'

Then he sang out to me a second time, 'Akara-ogun', and I answered him, 'Live long, live honoured; we are all children under your fold.'

And yet he hailed me a third time, 'Akara-ogun,' and I replied to him in these words, 'Kabiyesi, it is a veritable man whose name you call. I am indeed Akara-ogun, Compound-of-Spells; even as my name is, so am I. I am no morsel for the sorcerer, no witch can harm me, no prodigal-with-sacrifice dealer in charms can find a way to touch me.'

The king fell to laughing again and said, 'Seat you on my right.'

When I had made myself quite comfortable he turned to me saying, 'Akara-ogun my son, I have a mission to request of you, a most important one. And before I even tell you what it is I must ask you, will you perform this task for me?'

I hardly allowed the words out of his mouth before

I replied, 'Kabiyesi, this is a very small matter indeed. Wherever it pleases the wind even there does he direct the forest tops; the slave goes simply where his owner orders him — wherever you wish to send me, do so, I must go.'

This promise I made was a most thoughtless one. I had landed right in the king's trap and he began to address me thus:

'My child, are you aware that there is nothing on earth which surpasses well-being? And do you realise that there is nothing more deserving of honour than serving one's country? These two objectives have greater value than gold or silver, and it is on their account that I have to send you on this errand.

'Before my father died he was fond of telling me about the king of a certain city which is approached by the same route as leads to the Forest of a Thousand Daemons. The name of this city is Mount Langbodo. He said that the king of this place had a singular object which he presented to hunters who visited him there. He never mentioned the object by name but he did say that, if this *thing* came into the hand of any king, the king's domain would win an abundance of peace and well-being, and its fame would resound to every corner upon earth. Because you have journeyed into the Forest of a Thousand Daemons on two occasions, it gives me great joy to summon you today and beg of you from the very depths of my heart not to fail to snatch a brief glimpse of this same king and bring me this *thing* in his possession.'

When the king had spoken these words, I was greatly frightened. For a long time now, I had heard many tales of Mount Langbodo but had never yet encountered anyone who had made the journey and returned to tell the tale. Before anyone came into that

city he would first have to brave the length of the Forest of Irunmale, and that is only the beginning of the journey. It can hardly be regarded as a place on earth, because the dwellers of Langbodo hear, in the most distinct notes, the crowing of cocks from the heavenly vault. You can imagine how little I desired any part of such an undertaking, but the promise was made — there was no remedy for going.

'Kabiyesi,' I answered him, 'you are the father of all; and it is the truth you reveal when you elders say — even if the young man's wardrobe matches the elder's he cannot boast as many rags. I make obeisance. I learn now that although I boast numerous experiences in my past, yet, in wisdom, I am no match for you. With great cunning you extracted this pledge from me, and whether I wish it or not, I must go. Not that it matters, for it is my own country which I serve, go I shall. But I crave first a little favour from you. I want to send a crier round the entire land to summon all such seasoned hunters as I and send us together on this quest, that my head goes not forth alone to combat death. Nor will this be enough. Send messengers to all the neighbouring villages and homesteads that their bold hunters may join us on this mission to Mount Langbodo. If you would only do this, the matter is settled; only the going remains.'

The king was made happy by these words from me; immediately he commanded that my wishes be carried out and, within three days, hunters filled the palace courtyard. I looked among these men and I could not find one hunter named Kako. And I knew most surely that he should be part of an expedition of this nature, for a veritable strongman is he.

His history goes like this — his mother, a gnom; his father a dewild. Unfortunately, when their child was

born, his skin was almost human and so were his various members. His parents, ghommids both, were having none of this so they abandoned him in a hollow beneath an *ako* tree. A passing hunter discovered him, took him home and reared him. He it was who gave him the name *Kako* (a foundling by the *ako*). When we were children we played together and it was from this time that I knew what manner of being he was. When he was twelve he killed a leopard with a matchet and informed no one at home of his exploit. But when the creature had begun to rot, Kako returned to the spot and removed its thigh-bone, turning it into a club, and from then he earned the name of Kako-who-Wields-a-Leopard-Club. Hardly had my father died when his guardian also passed away, and when I went on my first adventure into the Forest of a Thousand Daemons he turned his feet into the Great Forest. A most evil forest is the Great Forest; its wild beasts are far more numerous than those of a Thousand Daemons, but the ghommids of the latter exceed those of the Great Forest. At the time this expedition was planned, Kako had not yet returned from the Great Forest and I had to go and seek him there.

I did not arrive at the Forest on the same day as I set out because I was late leaving town. I slept on the way and, about ten o'clock the following morning, I encountered Kako himself. When I saw him, I could not recognise him; he was all covered in palm leaves — I little dreamt that he was getting married to a ghommid on that very day. As soon as he saw me Kako leapt down from the tree on which he sat, ran towards me and embraced me; there was much rejoicing between us. He told me all his adventures since he came into the Great Forest and informed me also that he had heard great things about my own formidable exploits in the

Forest of a Thousand Daemons. He told me many, many things but I cannot begin to retell them in detail because such a tale would require a separate book of its own. And when he had done, I embarked on the chronicle of my own harrowing experiences; when I had finished we embraced each other again and flooded over with rejoicing, because it was indeed a meeting of strongmen.

All this while, I did not forget the purpose of my visit, and after a while I said to him, 'Kako, Wielder of the Leopard Club, my playmate since our childhood days, will you forbear with me while I iron out a little proverb?' And he replied, 'My dear Akara-ogun, hammer away, I'm listening.' So I continued with my discourse, and I said, 'You realise, don't you, that if a man's garments have not seen the last of lice, his fingernails cannot have flicked off the last of blood?' And he said, 'Yes, there is no falsehood about that.' So I continued and told him, 'Kako, until we have overcome all obstacles, can we really pause to rest? There are many goals left for us to conquer, many feats left for us to accomplish, many marvels waiting for us to perform; our country still lacks sufficient renown among nations beneath the sky. Were there no cause for it, a woman would not answer to the name of *Kumolu*; if there was not a good reason behind it, I would not come so early to seek you out. And the reason is this: many hunters, many of whom even lack our daring, are priming themselves for a journey to Mount Langbodo; they are going to battle dangers for the prestige of our country, and, when I had given this matter much thought, it occurred to me that you ought to go with us. If we do not go it is a matter of shame for us, and it would also appear that we only care about our individual selves and recognise nothing of our country's needs. And an

unworthy thing it is if one forgets his land, for let a craft voyage the oceans and voyage the seas, sooner or later it must head for port; no matter where we triumph in these forests, we must return home some day. My words are, I hope, worthy of your consideration my friend.'

Let us, unlike the mat unfolding on the ground, cut a long story short—Kako gathered together his possessions, got ready and followed me.

According to the custom of ghommids in the Great Forest, man and woman must live together for seven years before they undergo the ceremonies of a wedding. By then the woman would have given him children, and both man and wife would be thoroughly accustomed to each other's ways. If at the end of this period they find each other compatible, they get married—this, in their idiom, is a white wedding. If however matters stand otherwise, they take leave of each other with mutual satisfaction, the man to seek a new wife, the woman to hold herself in readiness for another man. It was this custom which accounted for the fact that I found Kako all decked out in palm leaves on his wedding day. You will have guessed from this that Kako had lived with his woman for seven years before our reunion in the Great Forest, and it is an amazing thought that throughout his preparations, and even up to the moment when he followed me on this wedding day, he had not informed his bride. It was most unbecoming behaviour.

But when the woman learnt of his departure, she flew after us, and, catching up, clung to his feet and spoke thus:

'What can the matter be, my husband? What trouble have I stirred awake? What offence have I committed to warrant this? In what manner have you

been aggrieved? Did you discover me with another man? Have I ever spoken in an unseemly manner to you? Have I neglected to show my love sufficiently? Were you told I brawl in public? Did you hear gutter language from my lips? Am I extravagant? Am I vain? Or is it that I am unclean in my habits? Are my manners careless or disrespectful towards you? Am I obstinate towards you? Or is it that I am a failure as housekeeper? Have I failed to look after your guests in a fitting manner? Could it be that I am simply a failure when it comes to seeing to your comfort? Don't I know how a woman talks to her husband? Or is it that I have failed to help you in your own work? What conceivable crime could it be? Tell me, please tell me, in God's name don't fail to tell me, my lord, my husband, my beloved.'

Kako replied and said to her, 'In truth, a woman who knows all these cautions you have set down could never offend her husband, and, unless I lie in the matter, I must admit that you have never offended in one of them, not even in the matter of late meals of which thousands of women are guilty every hour upon earth. But when a crisis comes, it comes, and that is that. At twilight, hundreds of leaves slumber on the bough; come darkness and beasts roam the forests in their hundreds—there is a time for everything; a time to play, a time to fight; a time for tears, a time even for joy; this is my time for departure, and my going will yield to nothing. Therefore, go on your way, and I on mine. If you find another husband, wed him; but do not count on Kako any more—the son of strangers departs on the business of his homeland—fare you well.'

On hearing these words of Kako, the woman burst into tears and entreated him again, but he made no pretence of listening; he simply grabbed his club,

stuck his matchet in its sheath and walked on briskly as when the office clerk hurries to his place of business. When the woman saw that the matter was past helping, she began to speak most piteously in the following words: 'Ah! Is this now my reward from you? When at first you courted me I refused you, but you turned on the honey tongue and fooled me until I believed that there lived no man like you. I gave you my love so selflessly that the fever of love seized me, that the lunacy of love mounted my head, that love's epilepsy racked me on your account. I could not eat unless I saw you, I could not drink unless you were with me; if I wished to go out you had to come with me, if I heard your voice anywhere I had to seek you there, and whenever my passion overwhelmed me I would leave my home and wander near yours, talking fast and loud so that you might know I was nearby. You know that I have neither father nor mother, that I have no siblings younger or older; alone you have replaced all these for me. Now when hands have clasped hands and feet slid in step you threaten to abandon me at the very height of day! You wish that I should become the laughing-stock of all the forest beings who will jeer and say to me, "You were so damned sure; well, tell us, can it be done?" Ah, may God judge you guilty you despoiler of lives!' And she wrapped herself tightly round Kako saying, 'You are going nowhere, not until you find some way to dispose of me.'

Our delay grew longer with the woman's desperate hold and Kako grew truly angry. His face was transformed and he pulled out his matchet, saying, 'Woman of death, mother of witchery seeking to obstruct my path of duty, know you not that before earth destroys the evil-doer, much good has already suffered ruin! Before God adjudges me guilty I shall

pass sentence on your guilt.' And, having spoken, be slashed her amidriffs, and it lacked only a little for the woman to be cloven clean in two; she fell on earth twitching in the final throes of death crying the name of Kako, crying his name into the other world. Great indeed was my terror!

We set upon the road and headed for home. We both slept at my father's house on that night, for Kako has no dwelling in the town. The following morning I went to the king and told him that it would be good to set a date for our departure and we settled for nine days hence.

For those nine days Kako and I made merry, for many of our friends who had lived in the jungle for a long time returned home and many times did we go and visit them, and we all together would set out on palm wine rounds; whenever the conversation turned on the matter of Kako and his wife, they all would tease him saying, 'Deal-me-death thrusts her neck at the husband — such was the wife of Kako.'

Like a light wind the seven days blew away and on the night of the eighth day Kako and I had prepared our packs and by dawn the following morning we had cooked yam, pounded and breakfasted on it. By half past eight in the morning we were ready and we proceeded to the palace where the king himself was already seated in state in the open air; the town was assembled, the crowd was numerous as an invasion of locusts on a farm. Several of the hunters had not arrived when we got there but by ten o'clock they were all assembled. Ah my friends, narrating is the poor brother of witnessing; these hunters filled the hearts of the beholders with awe. They were tall, garbed in hunters' smocks, their bags were slung over their shoulders, some wore trousers and others loincloths,

all of them had treated their guns with medicines and charms, they were black as oil soap.

I cannot give you all their names but will tell you a little about the most important six in the expedition, those who were the most intrepid and the most experienced. These, when I am included, made seven altogether. I will mention their names as they lined up in front of the king. The first was Kako of the Leopard Club, but his history you already know. Next stood Imodoye who is a maternal relation of mine. When he was only ten he was snatched away by the Whirlwind and he lived for seven years with him. In all those seven years he lived on a single alligator pepper every day. He was well versed in charms, wise and very knowledgeable, he was also a highly titled hunter. These qualities earned him the name of Imodoye, that is, knowledge fuses with understanding. I stood in the third position. Fourth was Olohun-iyo, the Voice of Flavours; he was the most handsome of all men on earth, the finest singer and the best drummer. When he drummed smoke rose in the air, and when he sang flames danced out of his mouth; his favourite music was the music of incantations. The fifth was Elegbede-Ode. He was a human child but had lived to maturity among wild animals, for when he was born he had three eyes, one at the back of his head. This led his mother to cast him in the bush, and there it was he began to live among baboons and grew immensely strong. After a while he returned to town and lived in the palace, but his nature was unruly, like the baboons, and this was what made men refer to him as Elegbede-Ode, for Elegbede is the father of the baboon. He stayed a long while with the king, the king bought him a gun and he turned to hunting. He understood the language of birds and the language of beasts, and was stronger than a lion. If you

hit him he felt it not, if you knocked him down he did not care at all; nor did an iron rod have the slightest effect on him. The sixth was called Efoiye. He was not a native of our town at all and I had never met him until the matter of Mount Langbodo raised its head. He was an archer and he really belonged to the family of birds, for instead of hairs he had little feathers growing from his body. He plucked them out all the time to avoid the jeers of people but whenever he was fully clothed no one could see them. He brought his wings into use only when deadly danger threatened him on his hunts. Wherever Efoiye sent his arrow there it went unfailingly. Even if he did not see the quarry it was enough that he ordered his bow to hunt it down and this it did without failing. But he was forbidden to shoot more than seven arrows a day if he wished to avoid the wrath of Sokoti, the Heavenly Smith, whose present the bow was to Efoiye's father. The seventh was the Miraculous Man, Aramada-okunrin, a relation of Efoiye on the side of his father. He was a most singular man, for when he was under the sun or inside fire, he would feel cold, but whenever the weather turned cold, he sweated from heat; everything about him was the wrong way round.

So we were quite a strange gathering who set out on this great expedition; when we were all paraded before him, the king gave us sound advice and, when he was done, Imodoye began to address the gathering thus:

'Fellow citizens of this land, we thank you for coming to see us today. This is the usage of fellow beings; you have acted as good-natured people towards us, you have given us stimulation, made us confident; you have raised our hearts' eagerness for this great adventure. If there is no cause the twig does not snap,

if there were no reason at all for it you would not see us gathered here today. All who you see before you here are bound for Mount Langbodo, and we go at the behest of our land. No matter how pleasant is the foreign land, he who boasts a home always returns home; no matter how delightful these strange lands may be to us, we will not fail to remember our home. If our town is small so that it looks like a bird's nest, yet the town is our town, if our city is filthy and looks more like a dung-heap yet the city is our city, if our nation is backward so that its citizens have not experienced civilisation, yet our nation is still our nation and only its own people will administer it; it is the people who will turn the dirt to cleanliness, they who must turn the small town into an important one. But whoever says that his birthplace is no longer his, that person is a half-witted fool. From the wealth of my knowledge and experience I know that this is a most perilous journey on which we embark; evil will join evil, tribulations will pile on tribulations; it is not as we leave you that we shall return. Many of us will never set eyes upon this town again. But when we are gone, do not forget us. And so I greet you on behalf of all my comrades, this blessed company journeying now to Mount Langbodo. We leave you our relations, we leave you our acquaintances, we leave you our homes, we leave you our paths; do not fail to take care of that part of us we leave behind. If we return, good, and if we do not, reunion is in heaven.'

When he had finished all the women burst out weeping and all the men were near to crying, but he turned to us and said:

'My comrades who go now to Mount Langbodo, make your minds resolute and act like men of strength. What glory is there to him who merely lives in luxury

but does no service for his land? What honour can an indolent man possess that will compare with that of a man of steel? I want you to understand that the skull of a lazy man is not worth the fingernail of a strong man; if his self-display flags for one single moment, the next moment his emptiness becomes revealed to all. Why then do I see you look gloomy? Sodeke performed great deeds among the Egba and departed; Ogedengbe fulfilled his share among the Ijesa and went his way; Ogunmola did wonders among the Yoruba and went his way. So now, I ask you, shall we fulfil our own task or shall we not?'

Imodoye's manner of speaking was very effective and it steeled our hearts. Together we all declared, 'We shall fulfil our share, let us go.'

And so we set our heads to the goal; all the people followed us. They accompanied us right to the border and returned home in tears. After they had all returned a certain old man followed us and, when all the well-wishers had returned, he stopped us and said, 'Listen you young fellows, as you proceed on this trip, watch out for acts of dissension among you. Remember that it takes two hands to lift a load to the head, it takes five fingers to lift the food to the mouth—make your counsel one. From this day on, do not remember your homes, follow the route which leads to your destination, watch only where you are bound. If wild animals attack you, fight them off, if evil spirits trouble you, trouble them in turn, and when you are finally by yourselves always re-assess your plans. If you pay heed to these words of mine, all shall be well for you, but if you reject them, that day is coming when you will say, Ah, that old man did tell us so.' When he had thus spoken, he turned back for home, accompanied by his tears.

I will not recount all our experiences before we

crossed the Forest of a Thousand Daemons; when I find some leisure we shall talk of these some other day, but I will not fail to mention briefly something of the kingdom of ghommids whose ruler was my good friend. I told you his story yesterday, told you how we met on my second sojourn in the Forest; it was in the place where I killed the one-eyed leopard. We called on his kingdom again and he took very good care of us, even providing plenty of food for our journey. He told me also that the dog which I was accused of stealing was not dead; that it was my enemies who took and hid it, in order to create an occasion to triumph over me.

Our plans accomplished in the Forest of Irunmale, we set our heads on the road to Mount Langbodo, and then, a memorable event took place. It happened thus: suddenly we were surrounded by a dense thicket and the trail vanished from our sight; we could turn neither left nor right, the thicket was like a solid fence and I doubt if a mouse could have found an opening for escape. We endeavoured to hack a way through this bush but the stalks grew back as soon as they were cut, and in the end we surrendered ourselves to death and dared whatever would happen to do its worst. But, in the evening of the third night of our confinement to this one spot, we noticed two big birds fly in and land on a tree quite close to us. Kako raised his gun to shoot at them but was stopped by Elegbede-Ode, and after a while Elegbede himself aimed his gun and shot one of them. Do not forget that Elegbede could understand the language of beasts, and it was the content of their talk which made him stay Kako's hand. One of the birds—the very one which Elegbede shot—had been saying to the other that Kako was the cause of our present predicament and that the occasion for it was the guiltless woman whom he had killed in the Great

Forest some days before, for this woman had cried for redress to heaven. The bird said also that unless he was killed and sacrificed and used in a rite of appeasement for the terrible sin of Kako, God would not relent towards us and we would never emerge from our imprisonment. This was why Elegbede killed the bird. According to our own usage, we split the bird open and poured oil in it; we placed it in a small potsherd and left it at the foot of a large tree nearby. The heart of God softened towards us — not because of the sacrifice itself, but because he knew that we would worship him in a more befitting manner if only we had a better understanding than this.

Shortly afterwards I had an inspiration. I remembered the woman who had rescued me from Agbako's clutches the other day, so I took some incense from my bag, made a little fire and began to burn it; I called on her to surface from the bowels of earth and performed the rites as a seasoned hunter. Shortly afterwards, she emerged from the earth before us and I told my companions thus, 'Look you, here comes the woman who rescued me from where Agbako imprisoned me; her name is Helpmeet.' And when she was near to us she asked, 'Akara-ogun, here I am, why do you summon me?' So I unburdened to her the entire tale of our great adversity, how we had sought a route of escape for three whole days, how Elegbede-Ode had overheard two birds conversing and how we had acted according to their revelation; that it was on account of this that I summoned her from the earth so that she might endeavour to release us from our present bondage.

Iranlowo listened to everything; when I was done she bade us follow her, and so we did. All the growth that surrounded us began to part before us as we moved forward. Soon we were once again on the road

to Mount Langbodo and she turned from us to resume her wandering.

We did not journey much after this before it was night and we slept. Hardly had the cuckoo cried the following dawn before we were up and setting our feet on the road, nor did we encounter any danger until about half past ten when we saw a man before us whose name was Fear, *Eru*.

When we saw the man we were truly afraid, for this man had four heads: one was human enough and faced the East; the second was like the head of a lion and was turned to the West; the third was a serpent's, its tongue darted incessantly and spouted venom—this was to the North, and the fourth was the head of a poisonous fish from whose mouth flared huge flames—and this was turned southwards. Myriad snakes were coiled around his neck and innumerable scorpions had made his shoulders their home: he was excessively hairy. Wasps and stinging bees flew round him in thousands and he caressed them as he walked. At his approach, a great gust blew and the forest was filled with noises, both timber and palm raised shouts of, 'Fear comes to the head of the disobedient, he is a sword in the hand of God to cut away the stubborn lest they become a hindrance upon earth.' This man was indeed a figure of terror and when he saw us he stood and watched. Kako and Elegbede moved towards him to join battle with him, but they could not close on him, chased back by wasps and bees. They made many attempts but all to no avail. Efoiye loosed his arrows on him but they did not affect him; each one of us made trial of our various powers but nothing seemed to affect him. In the end Imodoye advised that Olohun-iyo should sing a dirge, not the kind of tune which raised fire and smoke but a melody full of pathos which

would soften the man's heart towards us and make him take pity on us. Olohun-iyo performed according to the words of Imodoye; he sang how God created earth and heaven, how God loved mankind so well that He would himself visit earth from time to time as a friend, how it came about that the sins of man discouraged God so that he did not come any more, and all men began to flee from sin because it was an evil thing. The song told how, on account of this, any one who made himself a hindrance to his fellow men was the greatest sinner of all, insomuch as God once said: it were best that a millstone be hung from the neck of such a man, and he be cast into the ocean. And he sang that our journey had one motive only, namely to perform some good for our country, a purpose in which God took great delight. He sang also of our various tribulations in the past, the like of which was never experienced by human beings, and how only God could rescue us from any further hindrance in the pursuit of our goal!

Even as he sang he interwove the occasional spell and, before long, Eru turned tail and fled. Thus did we overcome by mere song a foe who was impervious to guns and bows, for whatever it is that man attempts by gentleness does not come to grief, but that which we handle with violence rebounds on us with equal toughness.

We returned to our route and walked on until it became dark and the wailing cuckoo began to cry. Each man laid his back to earth wherever was easiest, and slept off. God be praised that we woke up without mishap the following morning, and proceeded on our way.

It was about half past seven in the morning when we arrived at a certain town, and when we were about to enter, we observed a notice on the town gates which said:

Father of birds the Ostrich,
 this is indeed the King of birds.

The Creator does not object
 that anyone should kill a bird for food.

The Creator does not mind
 that birds be killed for a good purpose.

But whosoever has at any time
 wantonly killed a bird,

To him this town is forbidden.

This, had we but known it, was the city of birds, and the Ostrich was their king. If a man came into the city who had ever been guilty of the needless killing of a bird, a red mark, rather like a blood smear, would appear in a big globule before him, yet he might remain completely unaware of it. When we entered the city we knew nothing of this and had we not all stoned birds in our childhood and killed them without a purpose at some time in our lives? But we suspected nothing until their police arrested us and took us before their king, the Ostrich. This Ostrich I speak of was quite different from the normal run of ostriches. He was bird only from his neck downwards, the rest was human. His head was as big as a man's and it was shining bald in the middle. When he saw us he demanded with great anger, 'Who are these? Where did you come from? Where are you going? Doubtless you are thieves, and the mark of bandits is clearly branded on your foreheads. Therefore, prepare! Let loincloths be well secured and trousers belted tight, for I will show you a thing or two this day. I shall assign three tasks to you and, if you fail in them, most assuredly I shall slaughter you for food.'

Kako was furious and wanted to reply to him with defiance, but Imodoye restrained him. Imodoye then told the Ostrich, 'We have not come to steal, neither are we here to harm anyone. Our destination is Mount Langbodo, and if you have any task to give us, do so, but we do not wish to fight with you; we are here in friendship.'

It seemed as if their king was a little appeased on listening to these words of Imodoye. He told us that the first task, for which we would select one among us, would be to fight a certain wild animal who lived in his father's shrine. It was a lizard-shaped creature but one the size of four huge men and had a single horn on his head; this horn he used for pinning down game and it had never been known to miss. The king himself set eyes on this creature only once a year, and then only with the aid of spells and incantations.

As you all know, Kako was widely experienced in hunting, and when the king had made his demand, he quickly volunteered to go and fight the beast. This astonished the Ostrich and he was filled with compassion, for Kako is a most handsome man, tall and lanky; he was taller than the rest of us by a head at least. But when the Ostrich saw that he was indeed resolved to go he left him alone, expecting that Kako was going to meet his death. We also were greatly afraid, and it was with tears that we followed him.

When we arrived and entered the shrine, the Ostrich took us to the backyard where grew several fruit trees. In front of us, even as we entered this enclosure, was a narrow trail which led unswervingly to a little hut about two minutes walk from where we stood; this was the dwelling of the beast. This beast could speak like a human being and, no sooner did we come to the shrine than the king sent a messenger to inform him

that he had brought him someone for food. As soon as the message was delivered he emerged from the house, and when we set eyes upon him we fled each and everyone of us, the king included; only Kako stood his ground. He stood in front of a certain tree, leaning against it, and when the creature saw him he made a headlong charge in his direction and, from a few yards away, leapt at him with great strength to gore Kako with his horn. But Kako waited until the beast was quite close, then dodged nimbly so that the beast rammed the tree and the horn entered and stuck firmly within it. Kako rejoiced on seeing this, but instead of proceeding straightaway to cut the beast to pieces, he first of all took up a big stone and hammered in the horn more thoroughly. Then he pulled out his club and clubbed the animal to death.

Thus did he slay this brutish creature, and as he emerged from the shrine both man and beast were awe-stricken and the Ostrich raised his fist to him in admiration.

Thus ended the first task, but there was still the next. The king of birds called Imodoye and told him that we must again choose one among us who would prepare himself to fight the sand-elves. These elves were no taller than a foot, each was armed with a little whip, and they were numerous. Hardly had Imodoye delivered the news when Kako stepped out again and chose himself for the encounter. We all rejected the offer but he was adamant. Even as we argued it up and down our beautiful friend appeared to us—Iranlowo, the same woman who had rescued me from Agbako's confinement. She had a certain pouch in her hand and bade us let Kako go forward, so we agreed. Before Kako left, the woman gave him this bag and told him that as soon as the elves appeared he was to sprinkle

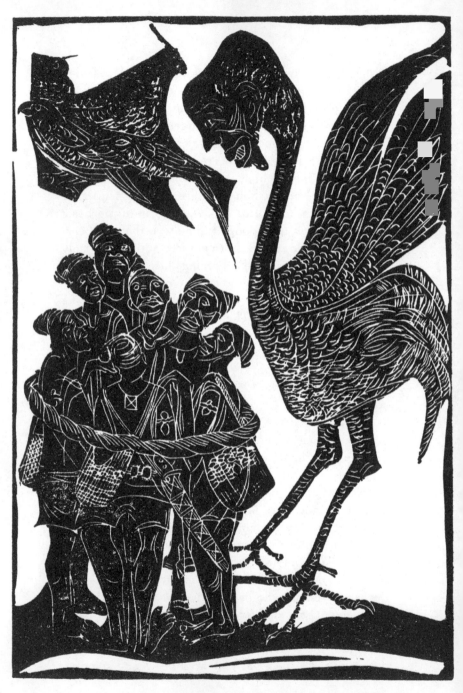

'Who are those? Where do you come from? Doubtless you
are thieves.'

them with sand from the bag. If he did this they would go blind and inflict death upon one another. She explained further that this sand was sand from the vault of heaven, created specially by the Creator for blinding those who stood in the way of others when they were engaged in a noble cause. She advised Kako not to take his club but he insisted he would; we all spoke in the same vein but Kako would not budge—he said, 'The shell never deserts the snail; wherever I go, my club must keep me company.' It was getting late so Imodoye put an end to the argument and informed the king that we were ready.

The Ostrich was astonished that Kako was again our choice, and he was persuaded that this indeed would be the end of Kako. He led Kako outside the city walls and we all followed them. When we had left the city and walked a little in the bush, we arrived at a flat open space which was full of sand and was bare of growth. It was about a mile wide in every direction and, when we arrived, the Ostrich paused, took a cow and slaughtered it in sacrifice to the sand-elves. Imodoye in turn quickly took a home-pigeon and a dove and offered them in sacrifice, saying, 'Honour comes home to the home-pigeon, ease is the nature of doves, this day must surely end in glory for Kako.' When Imodoye had finished the king threw water before him and began some incantations. After this had gone on for some time, we looked before us, and the sand-elves swarmed towards us numerous as locusts—we were truly afraid. Kako braced himself and went to meet them and when they saw him they ran even faster towards him. Before long, they locked horns with him as thousands of locusts might swarm over a small maize patch, covered him up as a thousand ants cover up food crumbs. Kako had forgotten what he ought to do, he pulled out his

club and began to batter them. In a moment he had despatched some fifty, but what are fifty among a numberless horde! They covered him in a pulsating swarm; those who could, stabbed him, those who could bite, bit him, those who could punch him did so, and still others pinched him; it was great agony for Kako.

When this had continued for a while and it had become impossible to see any part of Kako, Iranlowo told Olohun-iyo to start drumming, and to sing a reminder to Kako of his instructions. Olohun-iyo tuned up and began to sing and as he sang flames burst out and smoke engulfed us where we stood; as it was for us, so also for the king of birds and even the sand-elves, everyone forgot about the fight and began to dance. It was in the course of the dancing that Kako heard the words of Olohun-iyo; quickly he took sand from his bag and threw it on the elves and all of them went blind. After this Iranlowo told the drummer to stop and he did so, and upon this the sand-elves began to fight one another until only one was left, and this Kako killed with his club. Thus ended the second assignment from the Ostrich, king of birds.

Before we turned to depart, the king of these birds told us not to leave just yet, but to complete the third task right away. He told us that there was a being whose name was Were-Orun, Lunatic of Heaven. This man was so wicked that the Creator expelled him from heaven and sent him to the city of birds. He had hoped that perhaps, by listening to the dulcet voices of birds all the time, his heart would grow gentler and he would leave off his intractable nature. But rather than sing soft airs to soften his heart, the birds preferred to give him gory assignments. Whenever there was killing to be done they would summon the Lunatic from his den and hand the victim over, and instantly Were-

Orun would devour him, be he human or beast, bird or ghommid.

The den of this terrifying creature was not far from where we were, and when Kako declared that he felt like a little more exercise we left him alone to try his hand. When we arrived with the Ostrich at the lair of this being, the Ostrich called out to him. On the man's approach the earth began to tremble, thunder resounded and smoke gushed from the face of heaven — this was why our buttocks turned to water from fear, and I nearly excreted in my trousers. When eventually he himself appeared in the distance, his eyes were as kernels, and the breath from his nostrils like steam from boiling water. He came towards us and Kako in turn advanced on him; they met and they began to fight. His thought was to rip Kako in pieces in one second but the affair was not to be as he thought; Kako in turn also planned to tear him apart. They wrestled until dust rose to smother the skies and we could not see them both clearly—alas, that day's fight cannot be recounted fully in a book for time is flying. After a long time Were-Orun grew furious for he had never fought with a man like Kako. He spat on his hands and when he had muttered an incantation he rubbed the spit on his head and instantly his body was engulfed in flames so that Kako retreated fast and could not hold on to him. This angered Elegbede-Ode and Aramada the Miraculous Man and they both rushed on the man and began to fight him, but before long Elegbede could bear the heat no longer and he retreated. But Aramada felt nothing for his nature was different; the more he fought the colder he felt. Before long the fire was such that we could see neither of them, they were wholly engulfed in the inferno.

It burnt for about two hours before it died, and

when it had died down, it was the corpse of the Lunatic of Heaven that we saw. Aramada-okunrin sat upon it, and laughing said, 'I have slain him, come on and take a look; I do not even feel I have had a fight, except for a little cold which bothers me.'

And so we ended the three tasks which these birds gave us through the hands of their king, the Ostrich.

When we had completed them, the king invited us to dine and he cooked a sumptuous feast for us. Every man of us ate and was full; Kako ate the share of six men, and drank a full keg of wine. And when he had drunk and was quite tipsy, he moved close to the king and rapped him on the head saying, 'Isn't that some shine you have on your head.' This behaviour angered the birds and they attacked us, and when I observed that they seemed to be getting the better of us I took out one of the pods which the gnom had given me on my last adventure, broke it, and passed one pepper apiece to my comrades, swallowing one myself. The moment these peppers sank down wings sprouted from our arms and we began to fly skywards in full flight, but the birds flew after us and the fight continued in the skies. A most fierce battle this was, and during it we lost Janduku the junior brother of Kako and Ojuri the brother of Imodoye. In the end, however, we triumphed over these birds and headed for Mount Langbodo, still on the wing. We had flown for some time when Kako suggested that we return to walking on our feet, for flying as we were gave the appearance of our being afraid; to this we agreed. When I had served them peppers from a different pod and we had all swallowed them, the wings on our arms retracted and we resumed our march.

Not long afterwards we arrived at the kingdom of animals where we again experienced all manner

of things; alas, I cannot tell you all the details but I will share this tit-bit with you: it was there I lost my tooth—my canine tooth—and since that day I have been unable to chew properly. I became a ventilated mouth.

When we departed from the kingdom of animals, we crossed the indigo river and crossed the river of blood, we touched the country of the twelve-armed men and passed the abode of the seven viragos who weep incessantly upon earth. But how many should I recount, how many tell, how much can I tell you about the many encounters in these places I have mentioned! They were more numerous than lips can tell—the rest is silence.

We climbed a certain hill to the top, only to see Agbako coming towards us from the other side of the hill and, as soon as I set eyes on him, I cried, 'We are lost!', and when these travellers to Langbodo asked me why I cried thus, and I told them, Kako was furious and so were the rest of the fearless hunters in the group. Before Agbako came upon us, Efoiye shot an arrow; it hit him but it did not pierce him. He shot a second one with the same result. He shot a third but the target did not turn aside. And so on until Efoiye had shot all his seven allotted arrows which left Agbako still unharmed, and he came remorselessly towards us. And as he came to where we were, and Efoiye saw that Agbako turned his attention towards him, he shot the eighth, forgetting that he must not exceed seven in a day. This made Sokoti the Smith of Heaven exceedingly angry; he infused Agbako with strength from the dome of heaven and he threw confusion among us all. Desperate, I called upon God and he answered. Agbako fell and turned into a serpent and twined round Kako, knocking him to the ground, and he rolled

downhill from the top with Kako. When they reached level ground Agbako turned once again into a ghommid, upon which Kako summoned all his strength, lifted him up and smashed him to death. Thus did Kako slay Agbako and we resumed the toil of our journey.

Many hindrances did we encounter but there is not time to tell you everything, so I will mention just one more episode. One morning, as we made our way along, I caught sight of a man who went by the name of Egbin. In fact we began to smell him even before we set eyes on him. My good friends, since the day I was born into this world I have never encountered such a disgusting object as this man. All his toes were pocked with the jigger and they were so numerous that they had cut through several of his toes and infested his legs from the soles to the knees and many of them even came out of their own accord as he walked. The sores on his legs were numerous and he covered them with broad leaves, for the smallest of them was at least the size of my palm, many of them were left uncovered because these leaves could not fully cope with their size and they oozed fluids and pus as he moved. Egbin never cleaned his anus when he excreted and crusts of excrement from some three years back could be found at the entrance to his anus; when he rested, worms and piles emerged from his anus and sauntered all over his body, and he would pull them off with his hands; when he wanted to excrete he never stopped in one spot, he voided as he walked and the faeces stuck to his thighs and stuck to his legs. Every kind of boil and tumour lined the body of this man and each one was bigger than my foot, they burst open on his body and he would gather the suppuration in his hand and lick it up. Egbin never bathed, it was taboo. The oozing from his eyes was like the vomit of a man who has eaten corn

porridge, he stank worse than rotten meat and maggots filled his flesh. His hair was as the skin of a toad, grime from eternities was plastered on it, black he was as soap from palm oil. Earthworms, snakes, scorpions and every manner of crawly creatures came out from his mouth when he spoke and he would chew on them whenever he was hungry. The mucus never dried in Egbin's nostrils, this he used as water for cooking his food and he drank it also as water. My friends, only this little do I recall about this man, and when he came upon us and began to laugh, exhibiting his rancid teeth to the world, we begged him kindly to depart and after a while he went his way. But there was a man, his name was Oto, the junior brother of Aramada-okunrin, who followed him. He went with Egbin and up till this day we have never seen hair or hide of him.

We did not journey longer than three days after this when we heard the cocks of heaven, and we burst into a paved road which spread straight towards the dome of heaven. Even as we entered this road, we met two good-looking youths dressed in shining white, who when they saw us greeted us courteously and asked us where we were bound. We told them that we were bound for Mount Langbodo; this made them very happy and they gave us directions, saying that the road on which we were led straight to the dome of heaven and that after a while we would see the road to Mount Langbodo on the right side of the town gate, with this inscription — 'This is the road to Mount Langbodo; a town of wise men it is.' They told us further that if we followed the present road and did not turn at the fork for Mount Langbodo, we would find that this main road split after a while into two, the right side to the dome of heaven and the left to hell. They warned us to be sure to turn at the right moment

for Mount Langbodo because this turning was not far from the dome of heaven, from where hymns that were sung in heaven would reach us clearly; that if we were not on our guard we would be drawn onto the road for heaven and this would result in harsh visitations upon us, for it is the lifeless form only which man is permitted to take to heaven. The gatekeepers would not let us in as we were, and we would end up as food for the wild beasts or be turned into ghommids of the forests.

Thus they advised us and we thanked them, and before we had walked some distance heard the singing in heaven. Ah, how painful it is that I can find no words to convey to you the melodiousness of their music; I have never heard the like and we can never encounter such on this earth for all eternity. The voices were many but they sang as one; there was such unity. The song was so captivating that, when we arrived at the turning, we stood still, not wishing to proceed, and it was during our pause there that a certain man known as Keke-okun the brother of Olohun-iyo plunged into the road to the dome of heaven; he ignored all our pleas and even as we pleaded with him many more among us wanted to go the same way. So, seeing how we were all affected, Imodoye asked Olohun-iyo to sing and recall us to our mission, and he began to sing until the forests resounded and his voice echoed through the entire neighbourhood. Only then did our minds quicken to the road towards Mount Langbodo, but how Keke-okun fared we do not know till this day. Some said that the fearsome beasts had devoured him, others said that he was transformed into a ghommid, and others still claimed that the gatekeepers of heaven took pity on him, cloaked him in the garb of immortality and admitted him into heaven. But everyone merely puts forth his own ideas and we do not know whom to believe.

What is most certain is this important fact—that he departed before our eyes, but we did not witness his return.

We walked a long time but did not arrive at Mount Langbodo early and, when we were tired and it grew dark, we slept on the way not knowing that our destination was no longer far. When we woke up the following morning and examined our baggage, the food was exhausted and we were afraid that we would not arrive at Mount Langbodo before we all died of hunger. This would not have mattered if I had remembered to take the little cloth which was a gift from my wife on my second trip to the Forest of Irunmale, before she departed for her home at the Bottomless Bog. I forgot the cloth at home when we set out for Mount Langbodo; did I but have it in my possession, a prodigal feast would have spread before us the moment we demanded food.

Be that as it may, we did not walk more than a very short distance before we arrived at our goal.

Let the truth be spoken, Mount Langbodo is a magnificent city and a large one. Its beauty is beyond mere tabulation of details, its highways stretched out like endless lawns lined in bronze, the walls of buildings were built of mirrors, the doors of silver and the windows of gold. The king's palace glowed like morning sunrise, displaying the glory of God; the king himself sat lightly as a rainbow on his throne, his eye piercing and straight.

When we arrived at the city we sent to inform the king and he was happy to hear of our arrival; he ordered that we be fed and wined, and ordered that we be given clothes gladdened by sunrise and then brought before him; his servants did as he commanded and took us before him. When he saw us he warmed

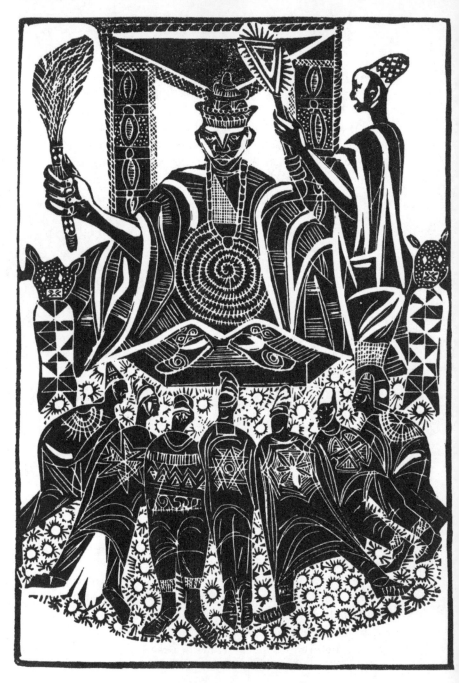

'Kabiyesi, King to whom honour is due.'

to us and embraced us, he greeted us with joy and we also honoured him and prostrated ourselves before him, saying with one voice, 'Kabiyesi, King to whom honour is due'. And after the exchange of courtesies he promised that he would help us to bring to a fruitful conclusion the purpose of our journey so that we could return home happy and contented to our king. But before he would attend to these matters we were to go and spend seven days with Iragbeje whose house had seven wings.

Iragbeje was a singular being and a very wise one; he was a man of keen intellect and this sagehood came with him from heaven.

Ogodogo is the potter of heaven and he it is who moulds the unborn children whom the Creator assigns to humanity every year. His occupation earned him the name of Ogodogo for, whenever he contemplates a new finished product of his craft, he rejoices and gives praise to God saying, 'The glory of God is apparent, the glory of God is turned to glory in the body of you, child.' He uttered these words every time and this led the inhabitants of heaven to nickname him Glory-to-glory, Ogodogo. When he had moulded the children, he took them to Sokoti the Smith of Heaven and both of them would fire the babies in the large furnace of Sokoti's smithy. When this was done the children were taken to God.

In the beginning of the world, after the creation of Adam and Eve our first father and mother, the intention of the Creator was that after these children were brought to him he would breathe life into them, and thereafter order that they be fitted with the smock of immortality in the home of Ogodogo, for the dresses in his house are varied; there are those of immortality and there are others of mortality. And the advantage

that this would have brought us is that we of this world could not die, and our grandfathers and mothers would also be alive today. Certain it is also that the wisdom of the world would be greater; the mighty stone structures which exist in Egypt till this day which were the brainwork of several generations past, and many other works of marvel which still astonish the world and which those who preceded us achieved through their cleverness would be clear to our understanding this day. However, the head was ill-fated and thus deprived the sheep of horns; the evil deeds which our forefathers committed changed the Creator's mind for him — instead of immortality he ordered that the children who were destined for this world should put on the smock of mortality so that the world would be one of taste-it-but-not-swallow for them. But on the day that Iragbeje was due for his own smock and he went to the house of Ogodogo to be fitted, he did not meet the man at home and, rather than await his return, he entered the clothes store, helped himself to one of immortality and fled into earth. And, even though God did not expect Iragbeje to behave in this manner, nevertheless, according to the course which God had himself plotted, the immortal fittings which were in the home of Ogodogo had such predominance over life that Iragbeje cannot die, for the smock itself is what God's own unique creations wear on the outskirts of heaven.

And so it is that Iragbeje lives in the world but does not die; that his eyes have seen much in the world and the wisdom of earth is clear to him. But after a while he grew tired of our world and he came to Mount Langbodo where he could employ the manifold wisdoms of his mind.

The house where he lived had seven wings, and the name of the house was in fact The House with Seven

Wings; he lived in one wing every day of the week; when he stayed in one today, he stayed in the other tomorrow. And on the day of our entry into Mount Langbodo, the king sent to let him know that we were coming to live with him for seven days. On that day itself, however, it was in the palace that we slept.

THE FIRST DAY WITH IRAGBEJE IN THE HOUSE WITH SEVEN WINGS

On the second day, the king ordered that his servants take us to Iragbeje, and when we arrived he took us to a large room at the very end of the house. My dear comrades, this room we speak of was of exceeding beauty; its floor was laid with the most precious stones, it shone like a mirror and was bright as a rockpool. In fact when we first entered it we thought that it had been built in the middle of a lake: the truth was that reflections from the stones created this illusion—ah, a most impressive man is Iragbeje.

There was a great variety of seats in this room and each one glittered like the lightning of heaven. When we entered the room and were seated, Iragbeje sat on the tallest of these chairs; we turned our chairs to face him and he began to address us saying: 'I greet you, brave hunters, I bid you welcome. Welcome from your long trek, welcome from the many trials, welcome from the hazards of the road. Did you not meet Agbako on the way? I hope Egbin did not trouble you unduly? How did you cross the river of blood? And did you not do battle in the city of birds? I trust that Were-Orun did not harm you? And the sand-elves? How did you fare with the wild animals? Welcome from your

tribulations. And the labour of rendering help to one another, of achieving unity among you; I salute your bravery, your endurance, your forbearance, your resolution, I salute your initiative, I greet you.'

We responded heartily even as he welcomed us and, when we had dispensed with courtesies, he continued with his address saying, 'I heard of your arrival yesterday; I heard also that you would be coming here to spend seven days with me, and since yesterday I have made arrangements over what we would discuss during these seven days and how we would enjoy our time together. According to my plans, it is the subject of children we shall tackle today, for it is the egg which becomes the cock, the child is tomorrow's father. I want you to listen carefully to everything I will now say to mankind in general, even though I speak as if I address but one man. So, let us begin:

'My dear fellow humans, you who bring forth children, train your child when he is still a child; remember that he is a gift to you, and do not let your child be lacking in home-training, lest you regret it after tomorrow, lest he become a slave to the child of another, and go from house to house to seek a decent meal. When your child wakes in the morning, find him work to do; do not with your own hands spoil him, do not grant him his whims day after day. When he transgresses, show him the error of his ways, when he is impertinent, rebuke him. If you are wealthy, do not indulge your child excessively, do not use another's child to indulge your own; remember that it is this indulgence which ruins the child of the rich, so do not let your child believe that he is the child of a rich man; don't take any nonsense from him, so that he asks this today and you grant it him, and he asks another tomorrow and you buy it for him also, revelling in destructive

indulgence, whining for attention and eating ten hunks of meat at one sitting.

'Remember that the world is inconstant and that you may become a poor man tomorrow, when a half-penny will prove an elder to you. If you are poor, cut your coat according to your size, do not envy the children of wealth lest you enter into eternal debt. A man lives according to his means. And, whether you are rich or poor, be sure that you control your wife; see that she does not spoil your children. Some wives improve the behaviour of children but others ruin them, for there is far too much human kindness in the sockets of a woman's eyes. Do not permit your child to keep bad company, that he start from youth to pub-crawl, insulting women all over town, dancing unclean dances in public places and boasting, "We are the ones who count, we are the elite over others." Then would calumny stick onto your child and people would sing, "He drank banana wine and was solidly drunk; he drank neat palm wine and was solidly drunk; he drank maize wine and was solidly drunk; he drank the wine, the wine of debtors and was solidly drunk, solidly drunk, he was solidly, solidly solidly drunk."

'If you hand your child to another to bring up, examine carefully what kind of person he is. Many guardians do not appreciate the value of a child; do not give your child to a man who is hard as stone, one who will inflict suffering on your child, nor should you hand your child over to the excessively soft-hearted who will merely spoil him. The grandfather and the grandmother are risky guardians, beware of them. If you find that you cannot avoid leaving your child with them because he will be of great help to them, well, it is not too bad, do so, but be not too far from the child, watch after your treasure lest it become ruined.

'Watch how your child speaks, rid him of lies, let not unseemly language pass his lips; don't let him utter things which do not go with the stomach, filthy discourse, disgusting words, boastful words and words which far exceed the language of children. See that he does not become a hardened thief in your hands and an inmate of prisons after tomorrow. If you have money educate your children, and even if you do not possess much, as long as you do not enter into debt and daily food is not too great a problem, try hard to educate him. If you have to cut firewood from the bush and sell it, endeavour to bring the matter to a successful end, bearing in mind that one brilliant child is not to be equated with a thousand children who have no training whatever; he is superior to them. Nevertheless, before you embark on this endeavour, see to it before you begin that you do not stop halfway lest people ridicule you in the words of the song, "Shame on you, shame on you, you made the promise but you cannot fulfil it, shame on you." The ridicule itself is however the smallest part of it, what follows a hundred and twenty far exceeds a hundred and forty; the name which your child now bears is worse than it was at the beginning, he is now a half-educated person. The half-educated feels ashamed to take up his cutlass, yet the amount of book-learning in his head is not enough to earn him a living; the half-educated wants to wear shoes yet his salary can hardly buy him a *buba*, therefore understand that if you cannot take it through to the end it is no compulsory matter: teach your child some useful trade. If it is farming, let him learn it well; see for yourself how the black nations are rich in land, it is a gift from their Creator to their great ancestors; if it is trading, teach him soundly, and if it is road-building, let him understand it thoroughly. Let

him not learn a little of this and a little of that, jumping from one thing to the other, as a man who chases two mice at once surely catches nothing. This is your time, prepare his for him; do not take out your resentments on him saying, "I will do nothing to help you for your mother is ill-behaved and is herself useless as a person." I want you to know that even if a child is as tall as an elephant and his girth like a buffalo's, a father is still a father. A child has but little sense, it does not exceed this much. The knack for learning is one thing, the knack for strutting another; if the moon appears by day and the sun by night, the wisdom of the old cannot desert the aged for ever. Therefore do not drag your interests in the mud; train your child now, that he does not become a worthless person in the world, so that he does not curse you after tomorrow and you go to meet Death with a broken heart.

'And now the matter is directed at you, youth. Young one, how is it? Have you forgotten your mother? Or do you not even remember her at all? I implore you, do not so, lest the father of hornbills pluck out your eyes for food. When you were little, hardly bigger than a mouse, it was your mother who wiped the mucus from your nose, her breasts you sucked and pulled at anyhow, even biting them, and it was on her clothes you defecated and pissed upon. It was your father who took up his cutlass and went after the bark of trees from which he made your potions, and your parents who ran hither and thither when you were taken ill. The clothes you have on today, the food you eat, come from them. I ask you, what is there left which they did not perform for you? It is fitting that you repay these kindnesses to them; the trade they teach you, face it, learn it well that it may suffice you and them for food. And if they cannot afford to send you to school, do not

therefore be angry, do not covet those whose parents have sent them to school, remember that the fingers of the hand are unequal; work hard at your trade, be it farming, clerical, or commerce, there is not that much difference between them—diligence at one's employment is the father of wealth. There are children who are frivolous children, who are never-do-well, who are the ruination of homes and ungrateful types; their fathers have gathered firewood and sold it to educate them; their mothers have gathered wrapping leaves for money to train them, and when they become people of importance they forget them. Perhaps this son earns three pounds a month; when his parents ask him for money he gives them a shilling, and when three months after they ask him for something he replies, "Why don't you slap me and wrest the money from me? Do you imagine that I pluck money from trees?" Ah, you worthless child, better take good care of your parents! Even if they do not have food worth a penny at home, even if they do not possess clothes worth a halfpenny, it was within this penury that they gave birth to you, and the day that they die you will understand that there is no concern as true as a mother's, and the father of another is never quite like yours. Give honour to your parents; they gave you birth. Even if you are educated, even when you become a doctor twelve times over, a lawyer sixteen times over; when you become thirteen types of Bishop and wear twenty clerical stoles at once, never condemn your father. Observe several sons of the black races who are brilliant in their scholarship, who have studied in the white man's cities but who adopt the entire land of the Yoruba as the parent who gave them birth, who love their land with a great love so that many wear the clothes of their land, *agbada* and *buba*, love to be photographed

in the clothes of their grandfathers; while others wear the outfit of Ogboni to show that they submit themselves to the country of Nigeria which is the great ancestor who gave them life, and show themselves humble to those who are their elders. I wish to tell you, child, it is your character at home which follows you outside; you who fail to give honour to your father can do no honour to the race of black people, and what then is the meaning of your existence?

'Consult with your father always, and he will regard you as a wise child. If your parents rebuke you, stay silent, show that their censure grieves you; never talk back when they censure you thus. There are certain children who never let their parents speak without interruption, daughters especially towards their mothers; when the father speaks one word the child replies two. And children who are even so bold that they raise their hands against their mother! Ah, how merciful is God, for were I the Creator, I would command the arm of such a child to stay up and never come down again! However, such children are not too common, and it is certain that if they do not repent in time they are asking for the ostrich of God to pluck out their eyes in the latter days of their life. I ask you, child, do you wish this? Sometimes your parents may wrong you; be patient, remember that when they approach old age some of their thinking turns again to a child's. I beg of you, do not earn the curse of your father, nor cause your mother to execrate your name; the curse of parents when the child is guilty never fails to hunt down the child.

'I have spoken much about children but I have not yet told you about the Ajantala type of child, those whose behaviour is turbulent and whose very nature is turbulence itself. I will not talk much about them, I

will simply tell you a little story, a most enjoyable story it is, highly entertaining. This is how it goes:

'Once a woman gave birth to a child, a very beautiful child, but no sooner was the child born than he began speaking out loud in these words, "Ha! is this how the world is? Why did I ever come here? I had no idea it was such a rotten place. I thought the world would be as spotless as heaven! Ha! Just look at the pit and look at the mound! Look at the cow-dung in the middle of the town! Look at dirt in the open. I have surely had it, I won't be long returning to heaven, no doubt about that." My brave hunters, it was a baby born that very day who spoke thus, and no sooner had he spoken than he rose from the spot on which he had been delivered, permitting no one to carry him, entered his mother's room and took from it sponge and soap, scrubbed himself gleaming, wrapped a cloth around himself and sat at a tense crouch. Not long after he turned again into the house and before he re-emerged he ate six large wraps of *eko*; he would have eaten more but there was none left in the house. And as he emerged it was a cry of hunger which preceded him; these goings-on were a wonder to the whole town.

'Before long the townspeople had heard and begun to arrive to see for themselves, but the child did not take kindly to them.

'On the seventh day, when it was time to give him a name, the parents filled the house with drinks and food spilled onto the road, and when the moment came to name him, he himself announced, "My name is Ajantala". From the moment that preparations began for the feast on this day we speak of, Ajantala had been simmering inside and, after a while, he entered the enclosure where the cooking was taking place, seized the ladle and began to stir the stew on the fire; this

flabbergasted those who witnessed it, and they said, "The plantain shoot kills the plantain; Ajantala will be the death of his mother." Such words of provocation to Ajantala! He seized a whip and thrashed all those who were busy about the food and scattered them. And his anger was further inflamed against the others who sat feasting, he waded into them and nearly flogged them to death; some well-muscled grown-ups tried to face up to him but his strength was more than theirs. In the end everyone commenced a rapid dialogue with his feet, calling on their gods for rescue: the Christians called to their Saviour, the Moslems called Anobi, the masqueraders called on their ancestors, Sango followers called on Sango, Oloya called on Oya. Ah, it was a most inauspicious day for the revellers, the confusion was great indeed. When Ajantala had had enough of the chase he returned home and began to hiss, muttering, "Do you say you have no sense, I will teach you all sense." Even as he spoke he entered his mother's room and smashed six plates; as he came out he trampled six fowls to death. A man who stood by said, "Ah, you child, what a cruel one you are!" Ajantala exploded six slaps in the man's face and, when he and the man began to fight, a passer-by tried to separate them and Ajantala gave the man six kicks. When he had done with kicking, he saw some men playing *ayo*; he deserted the fight, joined the players at their game, and defeated them six times. His elder brother who had observed all these happenings, opened his mouth and exclaimed, "Ha!" and his mouth tore wide open right to the back of his head. Ajantala had become a big problem.

'My strong friends, thus did this wonder child conduct himself with violence for a solid month and become a terror to the whole town and a peril to the public, yet no one could overpower him.

'There was a *babalawo* in this town, a most experienced man and well-versed in magic. From the moment that word came to him about this child he began to boast, declaring that there was really nothing to it; the child he said was a wanderer-child for this was the conduct of the wanderer type of children. The day he set eyes on the child, everything, he promised, everything would return to normal; he would show the child the power of his hand. He prepared himself, put on his wide trousers and then wore on top of them his loincloth of charms. He threw a large black *agbaδa* over himself, placed a round cloth cap on his head, filled his *ifa* bag with charms and medicines—things such as treated ores, gourdlets, powder gourds, cowries, beads strung from the spine of snakes and many other items of that nature, took up his: *ifa* bag and headed for the home of Ajantala. When he arrived he met Ajantala at meat, and when he had greeted Ajantala he sat down talking to the mother. The first thing that frightened the man was that the food before Ajantala was the food of ten men, and each morsel of the child that of six grown-ups, formidable. No one could dine with Ajantala and be full at the end of it. As the man was speaking with the mother, Ajantala's name came up in the conversation. "Ajantala" to his own hearing! He leapt up, slammed a lump of *eko* into the man's chest, took his bowl of stew and emptied it on his head, rushed at him and wrapped his *agbaδa* round his neck; he tore off his *ifa* bag and flogged his head with it, flogged him until the bag was torn to shreds, loosened the loincloth of charms from his waist and set on him with it. My good friends, when the punishment had truly penetrated right through to this man's marrow he cried out aloud, and when he finally succeeded in extricating himself from his *agbaδa* he left the *agbaδa* behind and took to

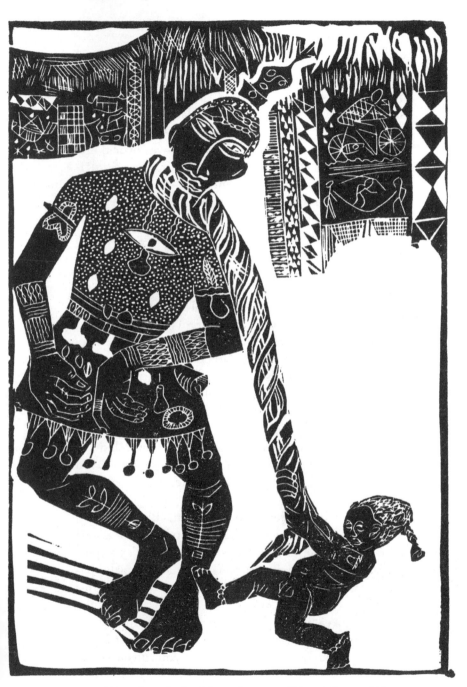

'Ajantala rushed at him and wrapped his *agbada* round his neck'

his heels; Ajantala ran after him, chased him right to his house before he returned. The man's body was raised in raw weals, nothing was left on him but his trousers, and he panted for long afterwards. Later the household came and asked him how it was over there, and he replied, "On that child's affair, never again! It is a very brute of a child; since the day I came into this world I have never encountered that which I met today. What did he not do to me! He beat me till I was near to death, he punished me till I was near invalided, he pulled and dragged me around as if the next thing was for him to slam my head against a rock. Ah, that child showed me a thing or two!"

'The affair astonished his audience and they said, "It must have been truly hard going yonder, that Baba should flee home in that manner. But did you not take your medicines with you?" Baba replied to them again, "Medicine or what else! Is it by the fire that a yam grows hairs? What are you fooling with? A creature who flogged the hell out of me and seized my *agbada,* who turned my belt of charms into a whip to castigate me, or do you even see my *ifa* bag with me? He has seized everything I own in its entirety, nothing saved me but my luck, so don't you imagine that this child is small beer."

'One of those present asked again, "But how! And where is your undervest? Did he seize your hat also?" This angered the man and he snapped. "Don't you pester me with any more nonsensical questions; the patriarch was burnt and you ask me what became of his beard! I say he took everything I possessed, yet you ask what became of my cap. Do you think if I had not fled he would not have taken my trousers also? Look, don't say I didn't warn you, if any of you runs into him and does not take flight, you are fooling with death.

And if you run home I will push you out again, I'm not letting anyone bring trouble to lay siege to my house!"

'Thus did Ajantala become a problem at home until the mother could bear it no longer; she took this turbulent child into the bush, contrived to slip away from him and returned home, leaving the child in the bush.

'As Ajantala wandered around in this bush he arrived at a place where lived five creatures in perfect amity—the first was Elephant, the second Lion, the third Leopard, the fourth Hyena, and the fifth Goat. Ajantala pleaded to let him live with them, that he would be a servant to them, and they readily agreed.

'These creatures took it in turns to seek food every day; while one foraged for food, the others stayed at home, and when the food was brought they all shared in it. Thus had they lived for a long time without any misunderstanding, that is, until this pestilential child came among them. He arrived in this place on an evening when it was the turn of Goat to find food the following day. Ajantala played the perfect guest the rest of that evening, he did not make trouble as he was a stranger among them. On the morning of the following day, Lion called the others together and suggested that, since they now had a servant, it was only sensible that whenever one of them went out for food, the new servant should follow him, and both Ajantala and the other creatures clapped in approval of Lion's proposal.

'When the morning had ripened a little, Goat prepared, and went into the bush for food. Ajantala followed him and, when they had both arrived at their destination, Goat began to seek food while Ajantala simply played about. Goat was silent, saying to himself that he would not make an issue of it at this stage, that the new servant was simply not yet experienced. After he had gathered food and tied it up in a bag, he called

on Ajantala to assist him in setting the bag on his head, but when Ajantala came to him he seized Goat by the legs, knocked him flat on his back and began to kick him until that unfortunate's face was in lumps and lacerations. Goat cried but found no one to save him and when finally Ajantala was done with him, he warned him, "If you tell anyone at home that I beat you, then you have truly spelt your own doom."

'After Goat had rested he heaved up his load and set off, Ajantala following. When they were nearly at their camp, Ajantala ordered him to transfer the load to him and he did so. Before long they reached the camp, and when the other creatures had taken but one glance at Goat they exclaimed, "Ha!", and asked what had happened to him. But instead of telling them the truth he lied and said, "As I was looking for food I upset a beehive with my head and they began to sting me; and when I retreated in the opposite direction I ran into a whole battalion of wasps who covered me up entirely; this was how my eyelids came out over my eyes, so that you cannot even see my eyeballs."

'The following day it was the turn of Hyena, and Ajantala again followed him out. When Hyena returned in the evening his face was swollen and his skin peeled off in thin wafers and, when they asked him the cause, he said, "Precisely what happened to Goat yesterday is what affects Hyena today; I fear it will happen to us all." Goat stole a covert glance at him and they both shook their heads, but Ajantala hardly took any notice of them.

'To cut a long story short, Ajantala gave them all the same treatment right up to Lion. On the night on which he served Lion his portion, the five animals met and decided that they must desert their encampment as the bedevilment was too much for them. Goat said it

was very obvious to him that they should not prolong the agony but leave the place the following morning, and this counsel was accepted by them all. Quickly they packed bag and baggage that same night, ready to decamp at the first light of dawn, but all their plans fell straight into the hands of Ajantala.

'When Ajantala saw that they were all asleep, he wrapped himself in leaves and entered the packed luggage (remember that Ajantala was not himself taller than a foot and a half). The following morning early they pressed their feet to the road in full flight. When they had gone some distance Goat felt a little hungry, so, planning to steal a little of the food in their load, he told the rest that he needed to stop and empty his bowels, that the others should go on and he would catch up with them; a lie of course, he merely wanted to steal some food. When they were out of sight he began to untie the load and, even as he took his teeth to worry the leaves in which Ajantala was hidden, like the wind Ajantala leapt out at him and beat him within an inch of his life. He knocked him to the ground several times over. Ah, it was a day which Goat would never forget. In the end Ajantala stopped, and ordered him to tie him back in the parcel and remain silent, told him also that when he caught up with the others he should hand the load to Hyena, hoping that the same temptation would come to that one and lead him to Ajantala's hideout.

'Goat took up the load and stepped out livelily. Shortly afterwards he caught up with his companions and they continued their march together. When they were gone some distance, he asked Hyena to take over the load because he was tired, and Hyena did so. The same idea as Goat's also occurred to Hyena, and soon he also wanted to empty his bowels of fictitious excrement. The beating which Ajantala gave him was

generous, no one had ever dealt him such punishment before. He wanted to cry out but Ajantala choked him, yet this Ajantala was no more than a mere stump. Hyena begged and begged for mercy but Ajantala did not spare him until he was thoroughly satisfied. When he released him finally, he told him to tie him back quickly in the parcel and warned him that if he did not compose himself at once he would receive another dusting-down. Instantly Hyena dried his eyes saying to himself, "The man who climbs a palm tree upside down will surely find what his eyes were seeking." Even so did this wondrous child beat them all, one after the other. The last was Elephant and, when Ajantala had got a grip on him, Elephant took to his heels and Ajantala sped after in pursuit. Before long they had caught up with the travellers in front and Elephant and the others shook the fluff of speed as one might worry out cotton; the matter became "if you won't move, clear out of my way!" Each one of them gave voice to different cries, Goat cried "Mme-e-e!", Hyena wailed, the voice of Leopard shook the ground, Lion rumbled like a rainstorm, and Elephant trumpeted.

'In the end Ajantala took a short cut to await them ahead, and sure enough he came out on the road ahead of them. He chose a large tree which was by the road-side and climbed up on it, hoping that when they came beneath it they would be tempted to rest. Not long afterwards they all arrived in headlong disorder, and when they came to the tree they decided to stop and rest, saying that it was quite some time since they last saw signs of Ajantala. If only they knew it, he was right above them.

'While they were resting, they began to talk and to revile Ajantala. They said: to think he is hardly more than a midget, yet, "If you punch him, it doesn't hurt

him, if you kick him he couldn't care less. Is this not a proper pestilence? Nothing but our heads can save us from this war which traps a man in his own house!" Then they turned on Goat and began to heap abuse on him, accusing him of responsibility for Ajantala's admission into their household. Goat said, "Ha, it wasn't I." But Elephant told him to shut up and threatened to stamp him to death, while Lion added, "Especially when a man is so hungry."

'Goat then rose to take an oath on his life, and he swore that if it was he who suggested that they admit Ajantala into their midst, the earth should open and swallow him, but if it was not he, some agency should bring Ajantala into their midst to scatter them! Does Ajantala ever miss a cue? He leapt down from above and scattered them to the winds.

'And from that day it came about that Goat fled to human habitation, Elephant to the home of the black race and to India, Leopard and Hyena into the depths of the jungle, but Lion chose to live in the plains. And what was the end of Ajantala? Did he perchance become a wanderer in the forests? No, the Creator from his home high up in the heavens saw the behaviour of Ajantala and knew that his nature did not fit into the ways of human beings. He sent a message from his throne and Ajantala was brought to the outskirts of heaven. This story was so widespread at one time that whenever one spoke about a truly vicious character one would say of the man that he is worse than Ajantala. And that is how the story goes, may your heads save you from a home-disrupting child, may your shoulders save you from the type also who sells off the home lest he sell you with your roof. May your legs and arms keep wreckers of life away from you that they do not ruin your lives for you.'

Thus did Iragbeje complete his tale. After which he said, 'Stout-hearted ones, too much talking leads sooner or later to lies; let us begin to enjoy ourselves and take our pleasure for the little time left before dark, tomorrow we will continue our converse with a different subject.' After this we began to eat various foods and to make merry, and the natives of Mount Langbodo came to visit us. And this was our occupation until it grew dark and we went to sleep.

THE SECOND DAY WITH IRAGBEJE IN THE HOUSE WITH SEVEN WINGS

The following morning when we woke Iragbeje took us to a different room which was twice as beautiful as the first one, and when we were seated as before he began to speak:

'Yesterday I spoke to you about children, but to-day I will talk about grown-ups who are the immoderate type; listen to how I proceed to address them:

'How now Mister Immoderate, have you now discarded this behaviour? If you have not yet done so I advise you to do it without delay, for disgrace is the goal of excess, and the immoderate is the father of the disgraced; the elder who puts on the cloth of excess will wear it to his own humiliation. We asked Immoderate to call us Sango, he got on the road and began to call on Oya. We asked him, how is your mother, and he replied, "My father is at home." But I ask you this, immoderate one, who set you about these activities? When a mature person has not the money for tea, he sticks to corn pap, a man who has not five shillings in his pocket does not embark on a pound project. A

sensible man examines his pockets before he spends money but the senseless says that what his comrades have done he must do also, forgetting that it is the home we examine before we give the child a name. Ah, you thoughtless one, do you know what your companion can count upon? Even if today you are not afraid of debts, when the creditor grips you tomorrow you will understand that a debt is nothing to be proud of.

'And I wish to warn you also, when a man offends you and admits his guilt to the extent of this proof, that he returns to ask pardon, be appeased in time. Remember that it is not your importance or your fame, nor is it your money nor your power that brings him to beg your forgiveness, but the love which he has for you. It is love which the world respects, not power; if you do not yield with grace you will become smaller in his eyes and he will dare you to do your worst. Dying you can hardly die, your head you cannot smash on the ground, all you would be left is your bag of shame and you would bear the burden of ridicule about with you. Immoderate one, remember that your second name is Start-what-you-cannot-finish, and the third Mulishness, and if you bear all these names, you will soon enough be condemned by those who love you; your friends and your close acquaintances whose admonishments have met with your indifference will not love you any more and will reckon you as nothing; they will say that you are a worthless man, and when your affair is in jeopardy some day they will turn their gaze aside.

'Nevertheless 1 want you to know that there is a difference between the immoderate and the well-meaning. Everyone knows the difference between evil and good, the Creator has given us that talent, therefore if you have resolved to do a good thing, even if a thousand people tell you not to do it, ignore them entirely;

if they call you names it is not your true name they give you for you are a good man. And when your efforts have turned out a success those who have held you in contempt will give honour to you. Therefore it is cleverness that the world admires and judgement which transcends every other thing, judge your intentions with your own values, know what is right as right, know what is befitting as befitting, do not do things as an immoderate man and do not act like a creature without a mind of his own.

'I want now to tell you a little anecdote to give weight to my words that you may see the end of the excessive man in the clearest manner. Once upon a time, there lived a lion in a certain bush, and he was the only lion in this particular place. This lion no longer wished to exert much effort in looking for food, for this reason he summoned all the animals in the bush one day and began to address them thus:

'"I thank you all for attending the summons which I sent out today, it shows clearly that you recognise me as your king. And you know also that I am not at all a wicked king; even though I have killed some of you for food before, nevertheless, I want you to understand that this is not really a thing I take delight in. Everyone of you has been allotted his diet by the Creator, and all of us are aware that when hunger enters the stomach no other matter has place within it; some of you eat leaves and this satisfies you, others treasure fruits for food, nor do we fail to see how the worthy wall gecko loves his meat. As you all know, it is among you that I select my meat, and since I hold you in such deep affection, I suggest that you all come to some arrangement whereby you will of your own accord come to me, one by one, to be killed for food. For by this arrangement you will all be privileged to know when death comes

to your turn, and he whose death is near will be able to arrange how he spends his remaining hours on earth. Furthermore, you must also be aware that I roar when I am hungry and without doubt this must constitute great terror to you. If, however, there is agreement, and each one knows when it is his turn to die, such roars will no longer exist, and the remaining animals will enjoy my company. This is how I have thought the matter out and decided to let you hear of it."

'When the lion had finished, his speech simply rendered reply superfluous. In the end, however, a hyena rose and said, "Greetings to you good people. I took note of one thing in the king's address: he spoke about the various types of food which each and everyone lives upon, and I think this was a weighty point in his speech. However, one thing occurs to me as good and proper and it is this—that if we arrange to go to the king one by one in this manner, it is not all the animals in the forest who should go. A beast like my own self, for example; I do not think that I eat less meat than the king himself, for even as I eat wild game so also do I eat domestic ones. The day on which I do not taste goat meat is a day which simply does not bear explaining. Therefore I think that if a third of the animals come to me and the rest to the king for eating, the matter will be so judicious that the king's name will never perish in this forest. This is what I see of the matter."

'After him rose the leopard, and he said, "Kabiyesi, king, this matter which you have brought before us is a straight one, and the words which were uttered by the hyena also had substance to them. One thing however I would like to impress upon this gathering, and it is this, if we all tackle the matter as hyena has tackled it, there is no doubt that few animals will be

left for the king. For if one-third goes to the hyena, I think it is fitting that a half come to me. For when it comes to killing game, the hyena certainly is no match for me, and if it is a question of speed, few animals can outpace me. As for beauty, well, you can see for yourselves that I am not lagging behind, for just as there is black on me so there is white. I think that if we exempt worthies like the antelope and the duiker, few animals surpass me in beauty. And if it is terror we wish to consider, I think that it is only in the crown that the king here surpasses me, for no lesser animal dares stare me in the face a second time; it is taboo. And as for eating domestic animals, I devour an entire cow and feel that I have not eaten—what do I want with a mere goat? Therefore my idea is that all those of us who are the nobility among the animals should be exempt from attending the king for slaughter; worthies like the elephant, lord of the trail who shakes the forest like a storm, for he is a warlord in his own right; and beasts like myself, the honourable leopard, noble of the jungle, the gentle fear which rocks the little child; and the hyena also may be exempt for he is the fourth in command to the king. Apart from these four, all others will come to the king for slaughter, and I think we ought to appoint the fox to arrange the names of all the prospective victims in a book so that each one will know when it comes to his turn; and there can be no doubt that the fox will perform this task satisfactorily for he is a man of great cleverness—I greet you in your deliberations."

'When the leopard had spoken thus the elephant supported him, and all the remaining animals shouted in approval.

'When the fox made out his roster of names, he put his name at the head of the list and followed it with

others. According to the table, the morning following upon this meeting was the time for the fox to report to the lion. Noon came but there was no fox; evening, and the situation was still the same. In the morning the lion sent for the elephant, leopard and hyena and complained to them how the fox had failed to turn up at the appropriate time, and yet his own name had headed the list. This astonished the three nobles and they sent for the fox immediately.

'He arrived before long and they all asked him what was the cause of his act of disrespect. The question had hardly left their lips when the fox began to give his explanation, saying, "Live long, prosper well, may you remain father of all beasts until the evening of your life, may you be saved the attack of hunters, may you avoid the danger of traps, if you are but one step away from a snare, God will surely warn you. Is it not clear that it was your love for me which made you assign this task to me? After all, what am I among all the other animals? On that day when you mentioned my name in the assembly I was most astonished, and my prayer is that God should preserve the fire of your love for me from an untimely end, that it will continue to burn strongly so that, when I die, you will not fail to take good care of my household. I want you to believe that I did not mean disrespect to you at all; it was simply the way events turned out. Do you see that mahogany tree over yonder? — and he pointed in that direction — even there lies my home, and do you see that *iroko* tree in the neighbourhood of the mahogany? — again pointing to it — by that tree live four beasts just like you: a lion, an elephant, a leopard and a hyena; they molest us animals who live nearby, and if you do not make the effort to get rid of them, hardly any animal will be able to come to your highness to fill his dinner table.

'This report was of great astonishment to these beasts for they could not think that there were other creatures in the forest like themselves. The lion replied and asked, "Is it indeed a fact that there is another lion in this forest?" And the fox replied, "Kabiyesi, it is so." And the lion again asked him, "Are you sure?" And the fox said, "I am absolutely certain; but this I see clearly, that although these animals are about your own size, they do not match you for strength for, although they chase me many many times, they are unable to catch me. And there is no doubt that if you fight with them you will surely overcome them and, once you have killed them, your livestock will surrender themselves to you at the agreed times."

'The way in which the fox told his story and the tone of his voice stopped the beasts suspecting for a moment that he was lying to them. They all prepared and followed him to where these animals were lurking.

'He led them all to the edge of a well which was filled with water and was very deep. When they came to it, the fox pointed into the well and bade them look inside it where they would discover the four animals he spoke of. When they looked inside the well and saw their reflections in the water, they bared their teeth and the reflections bared their teeth also. They tossed their tails with the same result. In the end they resolved to charge their own images and, even so did they leap into the well and die, swollen to a dead certainty. This is the end of the tale; the lion wanted to die the death of water and placed on his head the load of excess, saying that animals should walk in to him. I ask you, was that how they walked in to his forefathers?

'I have now done with the tale of the first immoderate, now to the tale of the second one.

'When the father of a certain man died, he left him a hundred pounds. The man used all this money to buy several sorts of delicate goods, all breakable things like jars, drinking glasses, all kinds of flasks, mirrors; a variety of dining plates and similar objects in which he wanted to trade. One morning he arranged all these things in a pile before him and, when he had revelled in the sight, he felt very happy and began to think aloud: "This hundred pounds of mine is no chicken feed. Is it not the amount I spent in buying these goods? Surely, if I sell them, I will make a profit of another hundred pounds and my wealth will become two hundred. And if I trade with this also, will it not become four hundred pounds? Surely if I have four hundred pounds I am truly in the money. How quickly does a man become rich! If I use this again to trade I will soon gain another four hundred pounds, and by such imperceptible means the amount now stands at eight hundred. But if I own eight hundred pounds have I not truly arrived? Immediately all men will sound my fame. Even then, the eight hundred pounds need not remain so, suppose I traded again with it? Surely it will yield more profit and a mighty profit at that, so my current standing could rise from this to some two thousand pounds. As a man worth two thousand, the entire town will have heard of me, my word will be law, but even if I owned this sum I would not stop there, I would trade until the two thousand pounds had become four, then eight, and so on up until I owned ten thousand pounds in ten thousand places. If I owned ten thousand pounds in ten thousand places it is only left for me to feast and dress gorgeously and parade myself that everyone may salute me in honour. However, a man uses money to seek money; before I rest on my laurels I ought to trade just a little more, so if I used this sum to buy more goods I

should approach ten thousand thousand pounds in ten thousand thousand places. Only now would I rest and take me a wife. But who should I marry in this town? Nothing less than a princess would do. When I have taken her to wife and she has moved into my house, I shall treat her with disdain—is she not my wife? I married her with my wealth and, princess though she is, it is my money which has brought her to me; or has anyone seen me approach her father's palace to beg for food? When occasion calls for it, I will reject the food she has prepared—this will surely make her unhappy; she will send for her mother to come and plead with me and, when they fall down on their knees before me pleading, I shall behave as if I do not know them. This will pain my wife a great deal, she will cling to my feet saying, "Please look at me, my husband, surely you know that I bear a great love for you. I would not intentionally punish you with hunger, it was the rain which fell yesterday that stopped the wood burning properly and caused your food to be late today. And I beg you fervently not to fail to be appeased by the sight of my mother on her knees to you, nor will I ever repeat the fault; sooner than make you go hungry I will seek firewood myself wherever it may be found." Undoubtedly I shall feel some compassion for her, but I ought to demonstrate my importance so I will kick her, thus . . .

'This man was totally lost in his make-believe, and he kicked forward even as he said, "Thus", and all the merchandise which he had purchased with a hundred pounds were smashed to smithereens. The squirrel ran up an *iroko* tree and the hunter was forcibly sobered; this man sobered up very suddenly. Mister Immoderate had no money yet but he had begun to kick a princess; if he does become wealthy the world will witness wonders.

'My good friends, I will next speak upon the twin matter of had-I-but-known and performing of good deeds. I will only speak a little on these and lend them weight once again by moral tales.

'A human fault is had-I-but-known and no one can totally eradicate the fault; earth would be nearly as beautiful as heaven if there were no faults on it. It is the very nature of this fault which has led our elders to coin the proverb, "Tears culminate in a sigh of self-pity, had-I-but-known is the end of tribulation; the elders all confess that the cure for had-I-but-known is yet to be found." Forgive me, but such is the proverb.

'About acts of kindness, it is true that men ought to perform these, but a man ought to know what sort of kindness he ought to perform and what kind of person deserves his kindnesses. Some people perform their kind deeds thoughtlessly, simply because they believe that such conduct is good, they do not think whether such acts are advisable or not. Anyone who performs acts of charity without thought does ill. A man who has two arms and two legs and has no deformity on his body, yet cries "Whoever God has given, let him give to me" is not the kind of man who deserves our charity. The kind of man who needs our charity is the one whom we see clearly as being incapable of providing for himself, no matter how hard he tries, those who have become very old, and the sick who cannot rise from one spot. Listen now to the story of one man and learn from it:

'One day a man was journeying to a foreign land and, as he reached the neighbourhood of a certain town, he saw a leopard in an iron cage. This cage was a snare set by the people of the town to trap the leopard which had been molesting them. The cage had been constructed in such a way that, once the leopard had

entered it, he could not free himself unless the cage was opened by some other person.

'When the leopard saw the man he pleaded with him to set him free, but the man said no. He begged and begged this man to release him until eventually he said, "How is it? What have I ever done to you? You think only of today, you do not consider tomorrow. True, the whole world calls me a wicked brute but I know that I am a kindly animal. You know yourself that the tongue of mankind is most inconstant, the same tongue that praises a man also reviles him, and if you were to live with me for three days you would swear that you wished yourself no other companion but me, I the incomparable leopard, noble of the jungle depths, who raises children without pinching pennies; and I want you to know also that if you do desert me I will not fail to find one who will take pity on me and set me free, and when we do meet again where will you hide? For certain am I that the eye will not fail to encounter the body after."

'When the man heard all this he said, "It is the truth you speak, and I understand it even beyond the points you raise. But even if fear does not actually seize upon one, a man ought at least to take note of fear. If I now set you free and you leap upon me and tear me to pieces, what would have been my own profit?"

'The leopard answered him, "If it is only this matter that bothers you, it is a very small point indeed. Hurry up, time is flying, open the door and set me free. I will not do you ill at any time and for ever."

'These seductive words from the tongue of the leopard made the man forget that matters stood at a confrontation with death, which is why a leopard may be seen employing his tongue to smooth his tarnished image. The man went to the cage and opened it, and

as the leopard emerged he leapt at the man to devour him. But the man pleaded desperately for a little respite to enable him to present their case to the first five people they encountered, begging that they submit themselves to the judgement of these five people; and thus the two proceeded together on the way. Before long they met a goat, and, as soon as they saw him, the man began to state his case, telling him how on his journey he had seen this leopard in an iron cage, how the leopard had begged to be set free and how after great unwillingness he had heeded the leopard's desperate pleas and set him free, and how the leopard had attempted to kill and eat him on the spot in spite of his great act of charity. When he had stated his case the goat said, "Slanderers by nature are the men of this world, they have not one jot of good in their nature. From the day I have been with my master, I have not known peace of mind for one single day; when I have just given birth he takes not the slightest notice, but when I have endured much to raise my young to adulthood, he seizes them for sale and goes and squanders the money on his own pleasures. When he has given me a little banana in the morning he leaves me to forage for leaves as best I can, he gives me no yam nor do fried plantains ever pass my lips, and when he has drunk and eaten, he seizes a stick and well nigh beats me to death. Therefore there is no good in the son of man, the leopard must kill and devour you."

'When the goat had delivered his judgement the leopard charged at the man to finish him, but he quickly reminded him of their agreement which still left the judgement of four people more, so they continued briskly on their way. Soon after they met a horse and when the man had stated his case, the leopard to one side, three of them altogether, the horse began his

judgement saying, "The tongue of men is as sweet as sugar, but their heart is as rancid as a sixteen-day-old stew. What this man has said may be true, but the evil man is the ruination of the good. Do both man and beast not know that I am the gentlest of animals? In spite of this, it is my very gentleness which human beings exploit to cheat me. They ride upon my back all the time and I carry them about, and on days when I am exhausted and cannot go too quickly they dig their spurs in me and thrash me with whips to make me race forcibly; sometimes when the suffering becomes unbearable and I grow very angry, I toss them off my back and they complain that a horse has knocked them down. Ah, I fear the handiwork of men, death is what you deserve from this leopard." And again the leopard made ready to attack the man, but he reminded him that there were three more people to be seen.

'They came next to an orange tree and the man again stated his case, after which the orange tree delivered his verdict thus, "Your case sounds good, no doubt about that, but I will never again take the part of you men, you are all no-good people. Is it not on this one spot I remain for all time, so that I do no one any ill? In the hot season men come and sit under my shade, enjoying the coolness; when I am in fruit, instead of climbing me gently and picking my fruits, they take stones and hurl them at me, they knock down my leaves until my body is all tender and I turn into a multitude of sores. Your cruelty is worse than that of monkeys, there is nothing for it but that the leopard must kill you." It was with the greatest difficulty that the man restrained the leopard after the judgement of the orange tree, and after some more walking they encountered a dog.

'Again the man outlined his case and the dog

again heaped imprecations on the sons of men and adjudged the case as the others before: there now remained only one person. They walked some distance and they encountered a fox. With tears in his eyes the man presented his case: "Dear fox, I know that you are a truthful person, and I beg you in the name of God kindly to judge this case as is truly fitting. I was minding my own business, journeying from home when I arrived at the outskirts of a town and saw this leopard in an iron cage. At first I hardly gave him a second glance but faced my own route and continued with my journey; it was he who hailed me and begged me most piteously to release him. I began by declining, saying I would not release him because he might be tempted to kill me once he was free, and, just as if I knew it from the start, this very thing is what happened and now he will not let me go; may God protect us from deadly encounters! This leopard begged and begged, persisted that I simply must set him free, promised not to harm me if I did so—but what happened as soon as I did? He leapt at me with indecent haste, declaring he must devour me; I only managed to persuade him to let another be judge of the affair, and this is why you see us thus. I implore you, save me from this predicament, may kindness never lead to your destruction."

'When he had finished, the fox gave him a most unpleasant stare and said, "And is this a sound case you think you have outlined? Even the things you have stated are unintelligible to me—can it be you are not aware that you are standing before the incomparable leopard? Do you not even tremble before the noble of the jungle depths? He who raises children without pinching pennies? If you want me to judge this case at all you must with greater calm restate your case entirely, and state it with humility because it is before a

Master that we both stand at this moment." The man began his story all over again and, when he got to the iron cage, the fox stopped him and repeated, "Do grant me a little patience, exactly what is an iron cage?" And the man replied, "A cage which is made of iron." The fox again repeated, "I say I want to know from you, what is an iron cage?" And the man replied this time saying, "Fox, I know that you are a very intelligent man, surely even if you do not know what an iron cage is you must know what a chicken cage is because your favourite diet is poultry. As a matter of fact, before all this trouble began, I had reserved two or three fowl which I intended to send you as a gift because of your good reputation among animals; they are in the habit of saying, 'A very good person is the fox.' And my intention still remains unchanged, the matter remains however in the hands of the leopard, if my head can sleep on my neck till the next dawn you will most certainly taste good chicken. If your preference is for mature hen I shall obtain it for you, and if you prefer a cock, they are all within my reach. An iron cage and a cage for fowls are no different from each other than in this respect, one is made of iron and is bigger than a chicken cage. I am hopeful that you will have understood this by now, do not fail to adjudge this case to the good, and may God reward you with blessings."

'The fox once more replied to the man in a hardened voice, and said, "You man, do you now turn me into a fowl-stealing fox? You are a worthless man, stupid, gormless, a nitwit, forest incendiary, if you don't take me to this iron cage this day I will not leave you alone, liar!" After which he turned to the leopard and said, "I make obeisance, worthy one, whoever shakes a mousetrap only shakes himself; whoever means you ill will merely harm himself; the animal who asks just

who you are in the forest deludes himself. I crave your indulgence that you accompany me with your wisdom, that we may follow this no-count fellow to this iron cage. I want us to nail him so that he has no escape, and, when I have delivered judgement, I shall myself witness your killing and eating of him." The leopard was very happy and he said, "Fox, the words from your mouth are delightful, proceed and I will follow." Thus did all three of them transfer to the place of the cage.

'On arrival the fox faced the man and said, "Where did you stand?" The man pointed in that direction and the fox said, "Then stay there so I can see you." The man stepped there. Then the fox turned to the leopard and said, "Save you sir, where were you?" And the leopard pointed to the iron cage and said, "It was even here." The fox replied, "Worthy one, I want you to understand that I am really a most stupid person, things sink very slowly into my brain. Unless you stand on the very spot where you were before I cannot comprehend the matter at all." The leopard briskly entered the cage. After this the fox said, "Now I begin to understand the matter." He then turned to the man and said, "You liar, I thought you said that you released him. How is it that he did not escape by himself if the door of the cage was thus left open?" And the man replied, "It was closed at the time." The fox again asked, "How?" and the man took the door and fastened it, saying, "Like this." The fox then asked, "And is that finally all of it, is it certain that the leopard cannot now escape?" And the man replied, "The leopard cannot escape." And after this the fox looked at the leopard and burst into laughter:

'"Salutations leopard, you have truly had it now, you will long remain there, you who make men tire of kindness, the riverside crow will surely pluck out those charitable eyes of yours. Go your own way my

good man and don't forget the fowls which you prom-
ised me. When you reach town tell the people that the
leopard which pestered them has now been caged, let
them come with arrows and with guns, with bows and
with full quivers, to give this ingrate his recompense."

'Thus was the leopard hoist with his own petard,
he thought and thought but could find no way out, the
fox needled him with six hundred jibes and the man
with seven hundred. The calabash of scorn burst over
his head, indelible ridicule stuck to his body, his eyes
blinked with rapidity, outwitted he was and hopelessly
floundering. The man did as the fox advised him and,
before long, the people of the town arrived and slaugh-
tered him. As he was dying he said, "Ah, is this how
miserably I end! If only I had used the grace which
God gave me in a fitting manner, this would not have
happened to me."

'Even so did the leopard regret his sin, but it was
too late; true, he repented, but the matter was already
at the conclusion, he stuck the finger of had-I-but-
known in his mouth and awaited what would be his
fate. May God protect us from such belated regrets.

'I greet you, my good friends, I think I have said
enough today, let us spend the rest of the day in mutual
enjoyment.'

And so we made merry until nightfall: there re-
mained five days of our stay with Iragbeje, but I can-
not tell you all the marvels which our eyes witnessed
and our ears heard during these five days, for time is
flying. I will go directly to our experience of the sev-
enth day.

THE SEVENTH DAY WITH IRAGBEJE IN THE HOUSE WITH SEVEN WINGS AND OUR RETURN FROM MOUNT LANGBODO

On the morning of the seventh day when we had break-fasted, Iragbeje took us outside and we did some sight-seeing round the entire city of Langbodo. It was quite late before we returned to the house and, when we had eaten lunch, we began to play—we raced, wrestled, leapt, somersaulted, we climbed trees and diverted ourselves in a hundred ways. In the end Iragbeje called us and led us into the only room that was left, for we had gone through the other six in the six days past. The seventh room was different from all the others; floor, ceiling and walls alike and every furnishing or article in the room, were all white as cotton fluff. On entering the room, Iragbeje gathered us before him, standing, and told us that we were not to sit down. He himself stood before us, dressed in a white robe, and began to address us thus:

'We have spoken about many things, but today we shall speak about our Creator. My good friends, strong ones, stout-hearted men, you fearless men who bartered death away in order to do your country good, I want you to know from this day that when men's tongues have run forwards and backtracked back-wards, if they still do not reckon with God, they de-ceive themselves, they indulge themselves in lies; it is really the seller of beans they see but they summon the hawker of maize. God is almighty. He is the One who makes good his word, our Creator. He is King of Heav-en, the Owner of Today, Clean Spirit, the Wondrous One, the Owner of Life, the Blessed One, the Prince of Glory, Dispenser of Goodness, the Mender of Ills,

the Sower of all good things, Protector and Defender, the One who Alone Is, and who shall be for ever and ever. And I want you who have come to Mount Langbodo to listen carefully while I tell you a short story so that you may understand how mighty a King is the Omnipotent One.

'There was a king, and a very powerful one; he was rich, was blessed with children, he had more territory than all the other kings and was gifted with uncommon beauty, but his character was evil. He was more wicked than the devil and more cruel than a monkey, more ill-natured than the thorns on a thorn-bush, and he spent his days with a perpetual scowl on his face.

'This king had forgotten that character is beauty and beauty is nowhere else to be found. In spite of his wicked heart, however, this king was a regular churchgoer. One day as the choir was singing in church and the organist revelling in his art, the king observed that one of the hymns was exceedingly melodious and that its sweetness far surpassed all other tunes. But since the hymn was sung in a different language he did not understand it, so he asked someone to explain it to him, and the translation went thus: "He removes the mighty from their throne and exalts the humble above them." My companions, the king was wrathful, sweat stood out on every pore and his eyes turned red with anger; if it were possible at that moment he would have shot the organist dead, if he could have done it he would have had the entire choir beheaded. He turned to one of his attendants and said, "Do remind me when the service is over to teach these heedless fools some sense; now I begin to understand why the service is always conducted in some language I do not understand! I see now that it is only a ploy to insult me. In all the four corners of the world, where has my fame not

resounded? What monarch does not know me? What chieftain dare refuse to reckon with my will? God has his own seat in heaven and I have mine on earth. I cannot remove him from his throne and I am certain that he also cannot unseat me on this earth."

'Thus spoke this king because he was in comfort. He made himself an equal to God and forgot his Creator, but God saw him from heaven and smiled. He spoke to the angel who stood by him saying, "Learn a lesson from this one, do you not hear what that undiscerning king has uttered? He has eaten and drunk to the full and now he has forgotten me. No day passes but I hear men grow arrogant towards my person, but rather than be angry with them or inflict grievous punishment upon them, I take pity on them and remember that I am their Creator. And what of this one who spoke just now? Is this not my own handiwork? If I desire to repay him in the same manner as he has acted towards me, what can I not do with him? I can turn him to a beast, and I can turn him into leaves of the forest. I can transform one half of him into animal and leave the other human, I can devise other punishments the like of which no one has ever seen to show him that I created him. But I will not do this to him; therefore, rise quickly and go and take his place, do not harm him but leave him room to repent: if he does repent, restore him to his position.'

'The angel heard and did as the Lord had ordered him. He left Heaven immediately and came to earth. Before a minute passed after this man had uttered his blasphemy, the angel had touched him and thrown him into a deep slumber. After this he turned all his clothes to rags and the gold at his neck to brass. The angel turned himself into a likeness of the king, exact on such details of eye and nose so

that nothing looked different from the person of the king, and he removed the king, placed him in a different spot and sat in his place, and everyone behaved to him as they would to the king; none knew that a transformation had taken place.

'While all this went on the king was fast asleep. When the service was ended everyone returned to his home and the church sexton shut the doors while the new king went to the palace, conducting himself in the manner of the former king.

'In the middle of the night the king woke up, and when he looked around him he could not tell where he was, so he rose and began to feel his way around. As he walked this way he stumbled against a pew, he walked that way and stumbled on a drum; the whole business was simply beyond his understanding, the place was pitch dark and everything turned topsy-turvy. After a long while he found the door and he pounded on it with desperation. When the sexton heard he hurried there to find out what was happening, and what did he encounter? Some ragged tramp emerged, so he took to his heels and fled back, believing him to be a lunatic. This was another surprise to the king, but he turned in the direction of the palace. On arrival he found that the gates were locked, but some people lay asleep nearby, and the new king the angel was deep in the heart of the palace. This tramp knocked on the door shouting, "Open the gates for me", and when those nearby demanded who he was, he replied, "It is I the king." The men burst into laughter saying, "Good-for-nothing drunk." This made him angry and he said, "To whom do you refer? You will scrub the floor with those same mouths in the morning." And even so did he continue to trouble them and speak ridiculously until one opened the door finally and came out just to see who had been

plaguing them. As soon as he caught sight of the man, he fled back inside and hurriedly locked the door, saying, "It's a madman, my mother was hardly born when this one began his lunatic career. If you go out to him you are surely finished." To cut the story short, this was where dawn broke on the king the following day.

'On the next morning he entered the palace and before he had walked some distance he was seized and taken to the angel king, for they were convinced that he was a madman. When the king saw him he took compassion on him, ordered new clothes for him and explained to the people that he was not really mad, but was only a jester who was good at amusing others. And from that day the king turned him into his own clown and gave him a house to live in within the palace. The former king could not fathom the meaning of it all, and he replied saying, "Is this a dream or am I upon the face of the earth, that I who was a king but yesterday should now turn into a clown today? These matters are totally beyond me."

'By casual stages the slip-on piece becomes a dress; a year passed and there was no change in this man's condition, sad thoughts plagued him like a debtor. After a while, he understood at last where he had erred and he was gravely smitten with the fear of God. This day was a Saturday, and on the following morning the first bells for worship did not ring on him in his own house; he was already in the house of God. When he entered, he fell on his knees and muttered a little prayer for the forgiveness of sins, and when the singing began he listened anxiously for the moment when the verse of that other time would be sung, and when he heard it — "He removes the mighty from their throne and exalts the humble above them" — he let out such a bellow of anguish that his throat was mightily

distended. My people, it was a most virile cry for this man had powerful lungs. And when people began to laugh at him he paid them no heed, saying to himself, "Laugh if you feel like it, turn cartwheels if you feel like cartwheeling, I alone understand what is hidden inside me; I merely bellow today and you burst out laughing, next time I will roar like a jungle beast before you."

'Soon the service was over and everyone returned to their homes but this man stayed behind. When he saw that the church was completely deserted he went near the altar and knelt, he pressed his face humbly to earth and prayed passionately to God. Later, he returned home.

'Not long after he had returned to his own house, the angel king sent for him and he went. When he appeared before him, the king ordered those who were with him to leave and they obeyed. When they were alone he rose from the throne and shut all the doors of the house and the windows also, and the room was pitch dark. The hearth leans back and watches preparations for fire, the bat leans back and contemplates the behaviour of birds; our man stood in the dark and waited for whatever was to befall him. Shortly afterwards, he heard the tramp of footsteps around the house, like the footsteps of a thousand men—the floor of the house and the walls began to tremble and a gust blew through the house with a great noise; it was time for the angel to reveal himself as the messenger of the God of Glory. Afterwards came a deathly quiet and a great light shone about the house, and when he looked up he saw the angel; he had transformed himself back into his own form, and revealed himself as the messenger of God. His clothes were white as snow, his eyes lustrous as precious stones, his skin clear as a child's and the shoes on his feet gleamed like bronze. The old

king was greatly frightened, he fell to the ground and covered his face with his hands. The angel opened his lips and spoke:

'"I am one of the seven angels who stand before the Lord. When you had fed well and drunk fully, you forgot He who created you—did you imagine that He could not see you? There is nothing upon earth which God does not see, nothing that happens in heaven which He does not know, for did He not create all things? But you set yourself high and began to behave like an unthinking man, you talked the language of the undiscerning until your Creator was angry with you. He called me and sent me to take your place, but He forbade me to kill you; and if you repented and turned back from your sinful ways, He said, I may restore you to your place. Inasmuch as you have today repented, his displeasure is ended for He is a merciful God. Therefore do I order you now, in the name of the God of Hosts, rise, ascend your throne and continue with your reign; if you employ well this grace, you will stay long on the throne, but if you abuse it God shall seize the throne from you." As the angel finished his words, he returned to his home in the dome of heavens and the king found himself back on his throne as in previous times; great was the awe of God upon him.

'And thus ends the tale, my friends who have come to visit us at Mount Langbodo; the hunting dog cannot catch his quarry and promptly forget its owner, we do not deck out a horse in glory and have him forget us; whoever forgets his benefactor throws away the benefits of tomorrow. Therefore when it is good for us, let us remember our Lord.'

When Iragbeje had finished his tale, he told us to begin to pack our effects that we might proceed to the palace, for we were to set off for home the following

day. We got ready and by seven o'clock on the seventh day of our stay with Iragbeje in the House with Seven Wings, we went to the palace of the king of Mount Langbodo.

On arrival we sent to the king who ordered that we be taken to the open grounds in front of the Court which had been lit up with myriad lights and was bright as daylight. He came himself at eight o'clock exactly and, when he had greeted us, he sent the following gifts to our king: six diamond rings, six gold chains, six beaded crowns, six velvet cushions, six household ornaments, and six bibles in six different languages. And, in addition, he gave us a letter which was written in a mixture of liquid gold and silver to deliver to the king, and these were the contents of the letter:

'Mount Langbodo, The Twenty Second Day of the Seventh Month in the Year Nineteen Hundred and Thirty Three after the Death of Our Lord.

To the King of the Nation of these following brave men — Kako, Imodoye, Akara-ogun, Elegbede-Ode, Efoiye, Aramada-okunrin.

Your Emissaries arrived here in good health, we rejoiced greatly when we saw them. I send you some small gifts in sixes, as is the custom of the Yoruba in days gone by and at other times even in the present age; I do this as a king who, with the symbol of six, seeks to draw you closer in my affection. My counsel about the progress of your land is this, let the people of your land love one another that they may value self-respect. If they hold dear the dignity of their persons they will not thieve, they will not gossip, they will

not be false, they will not be disobedient, they will not be arrogant; the children will hold their elders in honour, the elders will look after youth, there will not be found one blameworthy trait among them; and they will love God and love you also.

Give my good wishes to your people.
I am,
Yours in truth,
The King of Mount Langbodo.'

We slept at the palace till daybreak, and in the morning of the following day the king made us gifts of many things, and we turned our feet into the road, headed for our home.

I will not tell you of the various adventures of our return journey for they are too numerous. Doubtless it will sadden you to learn that it was not all who set out from Mount Langbodo who returned to our homes. And how did it happen thus? Many perished through simple conceit. The dupe of the world is the conceited man; he thinks that only when he struts and shows off does the world respect him, he little dreams that this is the very time that humiliation will reduce him. If a man overreaches himself, he crashes to the ground; if a house is overweening, it soon disintegrates; if a town is vainglorious, quickly will its disruption occur; if a nation is self-satisfied it will soon enough become enslaved to another; if a powerful government preens itself, before a bird's touch-down its peoples will disperse before its very eyes. When the delegates of Mount Langbodo were smitten with this arrogance, they listened no longer to the suggestions of others, amity had fled them and everyone behaved as he wished. But ac-

cording to the habit of our Creator, He employs two methods to punish the sinner, either He punishes him immediately or He notes down his sins in the record book. But with these men He did not adopt the latter method—instant was their punishment. When we got to the river of blood, we met the ghommids at play, for that was the day on which Olokun who is the guardian spirit of water celebrates his festival. Kako went to these ghommids and began to play with them; we warned him but he would not heed us. After a while the ghommids went down to the bed of this river of blood and Kako followed them. To this day we have heard no news of him. Efoiye and Elegbede-Ode said that they wanted to do a little hunting; they became ghommids in the forest and we never saw them again. And, when we got to the seven wailing women, Aramada-okunrin sat by them and declared that he would not continue with us, but Imodoye, Olohun-iyo and I returned home safe and sound, and we gave thanks to God.

When we returned, many of those whom we had left behind were dead, and those who remained did not even remember us for we had been gone a long time. When we came to the king he had aged a lot, his sight was uncertain but, when he remembered who we were and we showed him the gifts and the letter from the king of Mount Langbodo, he rejoiced greatly, embraced us and made us welcome. He gave us many gifts and from that day of our return we became men of means.

And thus ends the story of our journey to Mount Langbodo.

My friends, herein ends all that I mean to tell the world at this time. I want you to use this story as a mine of wisdom that your lives may be good. And so, fare you well, the native returns to his dwelling.

* * *

Thus did the man end his story and we saw him no more. But we found a little scrap of paper on the floor, and on it were the words 'Akara-ogun, Father of Born Losers.'

You men and women of Yorubaland, the wisdom of others teaches us not to think an elder a madman — put the story of this book to wise use. Each of you meets with difficulties in the world, each of you has his Mount Langbodo to attain, each of you has obstacles in front of him, for as there is sweet, so there is sour in this world; if today is good, tomorrow may be bitter, if tomorrow is bitter the day after may be like honey. The key to this world is in the hands of no man, as you pass through your journey in the world, meeting with good luck and encountering the bitter, accept everything cheerfully, behave like men and remember that God on High helps only those who help themselves.

My story is ended at last, let it receive solid kola and not the segmented, for the first is what secures a man to this world while the latter scatters him to the winds. And so, adieu for a little while, I have a feeling that we shall meet again before long; let me therefore utter a short prayer and then raise three cheers—the world shall become you, your nation will wax in wisdom and in strength, and we black people will never again be left behind in the world. Muso! Muso! Muso! I trust you have enjoyed this tale.

ABOUT THE AUTHOR AND TRANSLATOR

DANIEL OROWOLE FAGUNWA was born in western Nigeria in 1903. He wrote five novels in Yoruba. *Forest of a Thousand Daemons* was his first and most famous book and the only one to be translated into English. Fagunwa died on December 7, 1963.

WOLE SOYINKA, the first writer of black African descent to receive the Nobel Prize in Literature, is a Nigerian writer, poet, and playwright. He is the author of more than twenty plays and ten volumes of poetry.